# HAILSHAM

## THROUGH TIME

### Hailsham Historical Society

AMBERLEY

First published 2015

Amberley Publishing
The Hill, Stroud
Gloucestershire, GL5 4EP

www.amberley-books.com

Copyright © Hailsham Historical Society, 2015

The right of Hailsham Historical Society
to be identified as the Author of this work
has been asserted in accordance with the
Copyrights, Designs and Patents Act 1988.

ISBN 978 1 4456 3766 2 (print)
ISBN 978 1 4456 3778 5 (ebook)

British Library Cataloguing in Publication Data.
A catalogue record for this book is available from
the British Library.

Typesetting by Amberley Publishing.
Printed in the UK.

# Introduction

The Hailsham Historical and Natural History Society's collection of photographs is a rich source of history and information about our town, and many early pictures are on display at the society's museum in Blackmans Yard, Market Square during the summer months. However, when we came to compile this book, we were keen to show photographs that were also within the living memory of people who are familiar with the town. Our appeal to members and friends for long-forgotten views, together with the society's own pictures, brought a wealth of material taken over the last 150 years, almost all with pre-digital cameras. It took many pleasant hours to sift through and work out which ones represented 'Hailsham Through Time' most appropriately, and we hope that you enjoy our final choices.

There is no doubt that Hailsham has undergone an enormous amount of development and expansion since the early part of the nineteenth century. Census figures show how the town grew from a population of just under 900 in 1801, when the town was no more than four streets and a few twittens clustered around the church and Market Square on the edge of Hailsham Common. Some of these early buildings can still be identified today, walking from the Square they formed the High Street as far as Vicarage Field and Carriers Square, in George Street to Cortlandt, Vicarage Road to The Stone, and along Market Street to Bellbanks.

Hailsham has no real strategic reason for this development except that it is centrally placed in a large rural area and was granted a Market Charter 1252 by Henry III. In the nineteenth century, the rope industry, brickmaking, the coming of the railways and the enclosure of the common all contributed to the town's expansion. Between 1870 and the outbreak of the First World War, the town's population almost doubled from 2,429 (1871) to 4,604 (1911), and many houses were built in the new roads that sprang up around the town.

Building after the Second World War has seen the town expand with housing in all directions, especially in the north where the border with Hellingly is difficult to distinguish. Housing has also taken over the land between the town and the bypass to the west and further development is taking place up to the edge of the Pevensey Levels to the south and east. Our population has grown to more than 21,000 and is set to continue at a pace over the next few years. The town centre shops now fill the central area bounded by Vicarage Lane, George Street and North Street, and light industry is well established in areas off Station Road and in Diplocks Way, between South Road and the bypass. Our railway was closed in 1968 after the Beeching Report, and sadly it has recently been reported that only one working farm will be left in the parish in the next few years.

We have also noticed a number of striking changes through the photographs. The first is that Hailsham does not have a good record of preserving and reusing its old and sometimes historically important buildings. Many have been demolished over the years and some are illustrated in this book. The second is that those older buildings which do survive have mostly had their chimneys removed, which sometimes makes their appearance quite unbalanced. The third is that nearly every modern view is dominated by cars and street furniture – nothing was more obvious than this when we were trying to photograph scenes in the present day.

As this book goes to press, Hailsham is due to have a number of major improvements made to the junctions, road alignments and pavements of High Street, George Street and Vicarage Lane in order to enhance the town centre's accessibility. Some of the present-day views that we have included may have changed by the time you read this book – just another example of the way our town develops 'Through Time'.

Summer, 2015

# Acknowledgements

The Hailsham Historical and Natural History Society would like to give a special thanks to two of its members. This book would not have happened without the enthusiasm and hard work of Richard Goldsmith, who collected, prepared and copied the old views and took all of the present-day photographs. Thanks to Alan Hibbs for his contribution – compiling, checking and editing the captions. Thanks also go to our Secretary Maxine Kitcher and to our Chairman, David Bourne for their invaluable help and encouragement and for keeping the project on the straight and narrow. We would particularly like to thank the members and many friends of the society who loaned photographs of the town, many of which have been included within this book

Photographs included in this book were kindly loaned by the following: Jackie Battams, David Bourne, June Bourne, Bob Catt, Delia Cottingham, Mary Jo Fanaroff, Richard Goldsmith, Rosemary & Alan Hibbs, Maxine Kitcher, The Pitcher family, Nicola Stone, and the Hailsham Historical and Natural History Society.

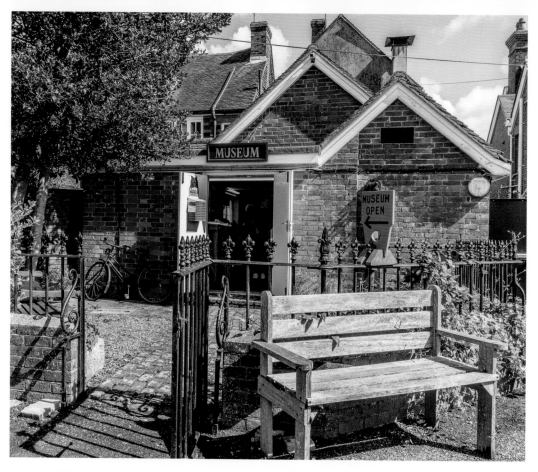

The Hailsham Historical & Natural History Society meets at 7 p.m. on the second Wednesday of each month, except July and August, at The Methodist Church Hall, High Street, Hailsham. Visitors are always welcome.

We also have a small Museum and Heritage Centre in Blackman's Yard, Market Square, Hailsham, (behind the Hailsham Town Council Offices) which is open on Friday and Saturday mornings from 10 a.m. to 12.30 p.m. during the summer – May to September.

The Society is always interested in copies of old photos and documents or artefacts relating to the area.

Please contact our Secretary Mrs Maxine Kitcher for further information Telephone 01323 843206.

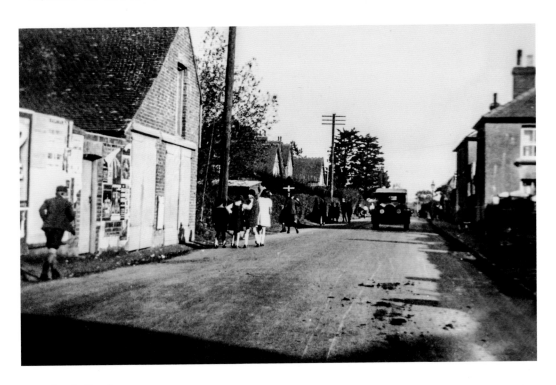

**Battle Road, *c.* 1930**

On the way to school: the building on the left became Daddio's coffee bar in the 1960s and later the local Liberal Democrat headquarters, and the houses opposite are painted white. The junction of Battle Road with London Road is also now controlled by traffic lights and an additional pelican crossing has been installed by the school entrance. The road here today is very busy, especially during peak hours, which is so different from the odd car in the thirties.

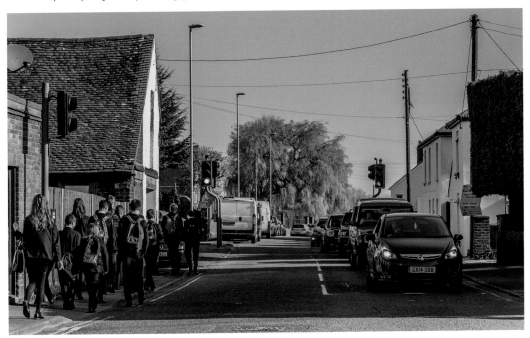

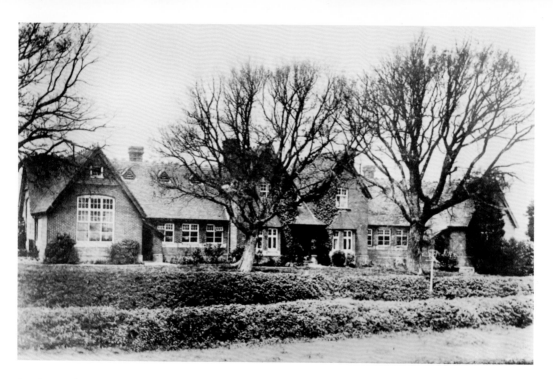

**Battle Road, Board School, 1878**

The original school building, surrounded by neat hedges, which was opened in 1878, is still recognisable today as only the windows seem to have been changed, but the school has been enlarged considerably over the years with many more buildings dwarfing the Victorian structure and a high brick wall added on the roadside. The Board School is now called Hailsham Community College and became an academy in 2012 (inset) and has around 1,200 pupils today.

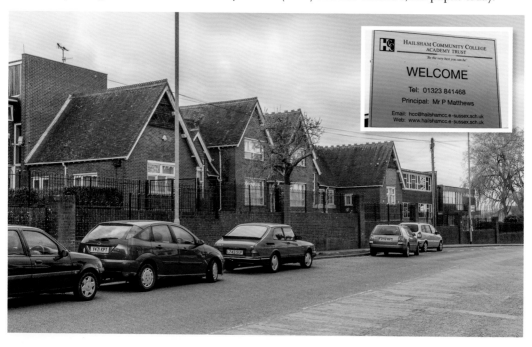

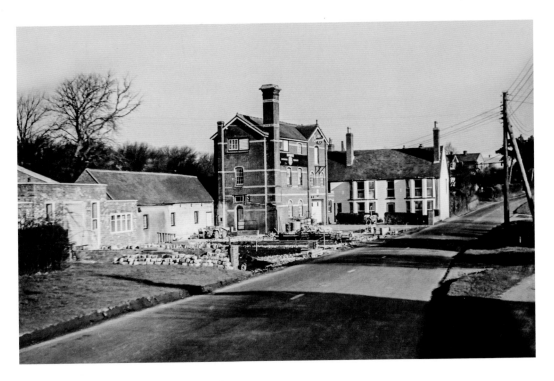

**Battle Road, Bowes House, c. 1965**

The brewery in Battle Road was in existence by 1827, and in 1887 the fine new brick building in the centre was added by Mr D. N. Olney. The site was used later by Apaseal, a tyre maintenance and equipment company, who were adding new offices and another warehouse when this photograph was taken. Earlier this century, all of the buildings except Mr Olney's were demolished and rebuilt as a care home in 2013, with the brick building beautifully restored.

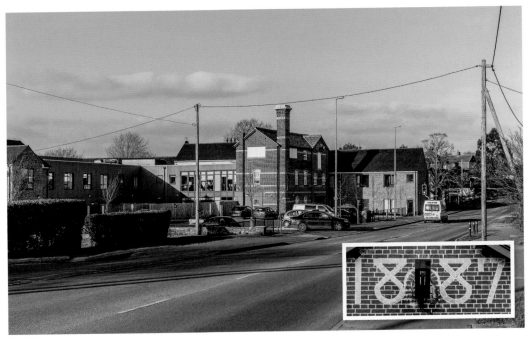

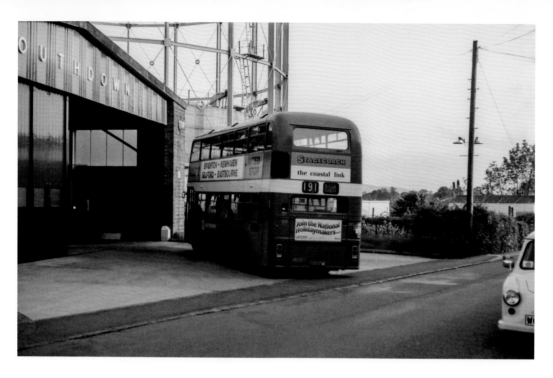

**Bellbanks Road, Southdown Bus Garage, 1986**
The Southdown bus garage was built in 1965 on the site of the former Butler's steam-driven sawmill at the corner of Bellbanks Road and Mill Road. This was demolished in 1989 and the Southdown Court sheltered housing and retirement home was built on the site and was opened in 1994 by the Beverley Sisters. The gasometer next door was also dismantled and a small housing development built in its place.

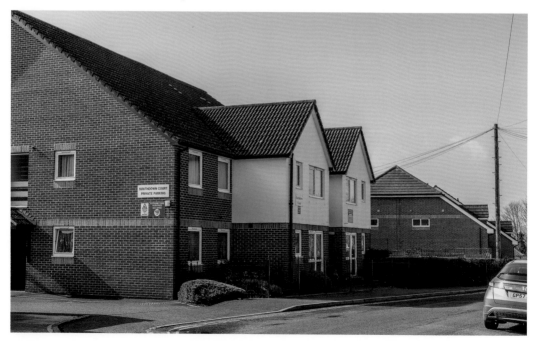

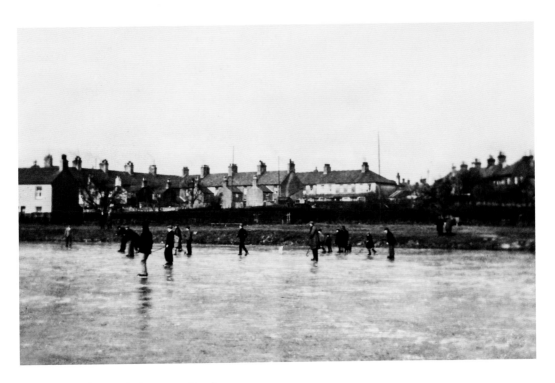

### Bellbanks Road, Common Pond

In the 1920s during cold winters, the Common Pond was used as a skating rink, where ice hockey was played with walking sticks. At some time a brick wall was built around the edge, and in 1996 a second island was formed in the middle of the pond following extensive improvement works. Houses have been built on the other side of Bellbanks Road and in Nursery Path, which back on to the terraced houses in Station Road and Terminus Place.

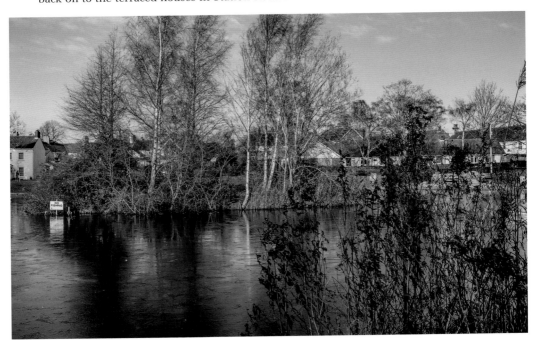

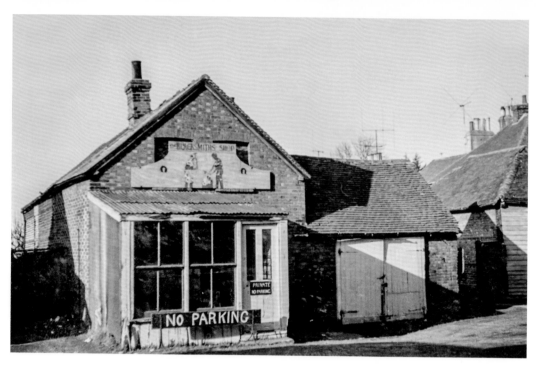

**High Street, Carriers Square, The Old Forge, *c.* 1965**
The blacksmith's forge stood locked and unused for several years, but full of tools and equipment with this No Parking sign outside on a pair of metal brackets. The building to the extreme right of this picture, between the forge and the chapel, was a carriage-builder's workshop many years ago, but has since been demolished. Considerably refurbished, the shop has been occupied variously to sell wool and tropical fish, before being used to sell and service bicycles.

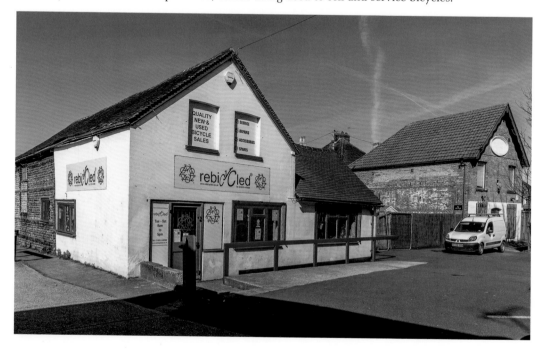

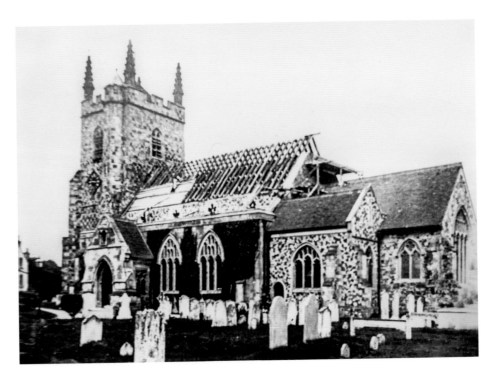

**St Mary's Parish Church, 1889/90**

At some point between the fifteenth and nineteenth centuries the nave roof was lowered. In 1889/90 it was restored to its original height, and here we can see a workman preparing for tiling. The single clock face on the tower, which only had one hand, was replaced by the current one with two faces (and two hands!) for Queen Victoria's Diamond Jubilee in 1897. Part of the original clock face can still be seen in the Historical Society's museum.

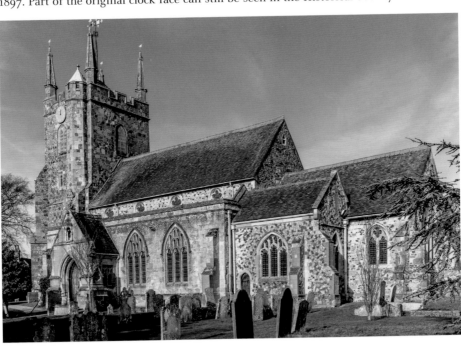

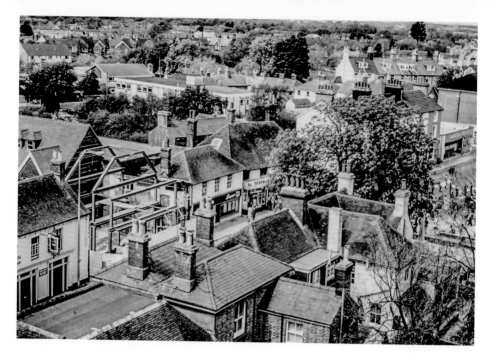

**Town Centre from the Church Tower Looking West, 1984**
The complete reconstruction of Piper's shop in the High Street was underway when this photograph was taken and the new steel frame had only just been erected after the original building had been demolished. The Quintins Shopping Centre has replaced the flat-roofed Social Services building facing North Street and the buildings to the right of this picture in the High Street. White House School (at the top left) has since been replaced by Tesco's car park.

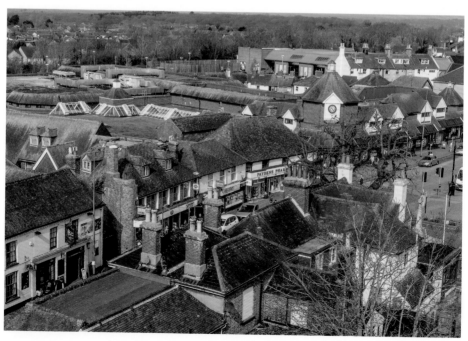

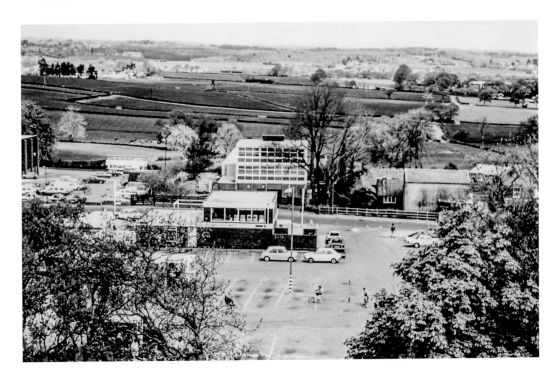

## Looking North from the Church Tower, 1984

The petrol station in the Vicarage Field car park was demolished in 1996 and the car park extended. Only the leisure centre, telephone exchange and Seaforth Farm stood between the town and the open farmland, but now the housing dominates the middle distance. Even the farmland beyond is earmarked for development shortly. The Charles Hunt Day Centre, which was built in 1987, is now also visible in the foreground.

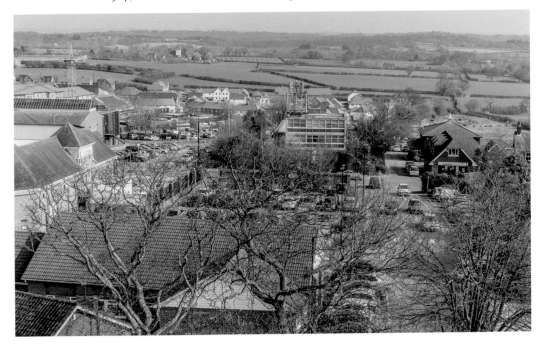

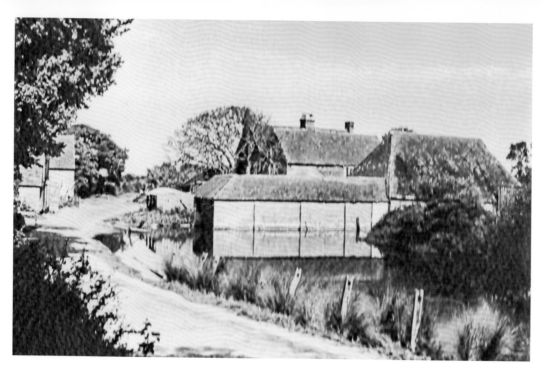

**Rickney Lane, Downash Farm** *c.* 1935

The Hobden family farmed here in the thirties when the farm buildings were on both sides of the lane, next to the duck pond. Today the barn between the pond and the farmhouse has been replaced by a timber stable block and the buildings on the left-hand side of the road have been converted into homes. Nothing much else has changed: the lane still meanders past, but the pond is a little more overgrown with trees and vegetation.

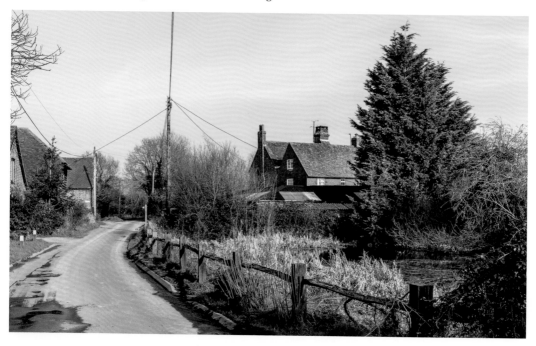

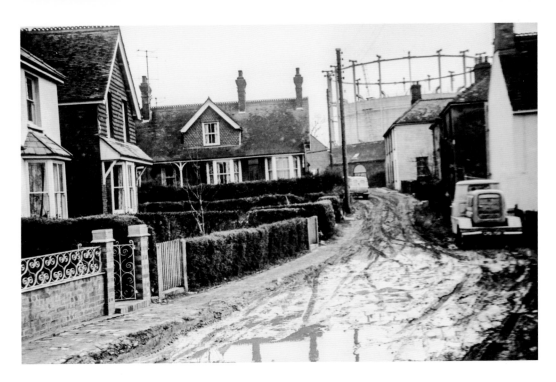

**Elmsdown Place, 1964**

Some of the roads in the town were unmade for many years and they turned into a quagmire in the winter months; it was several years before Elmsdown Place was metalled. The gasometer in Bellbanks Road is about three-quarters full, but on the site now is a block of flats and the housing development of Fletcher Close. The house on the left, end-on to the road, has been replaced by Ashford Close, and Elmsdown Place is now a quiet cul-de-sac.

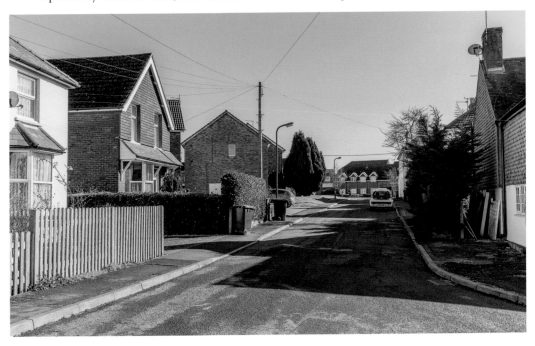

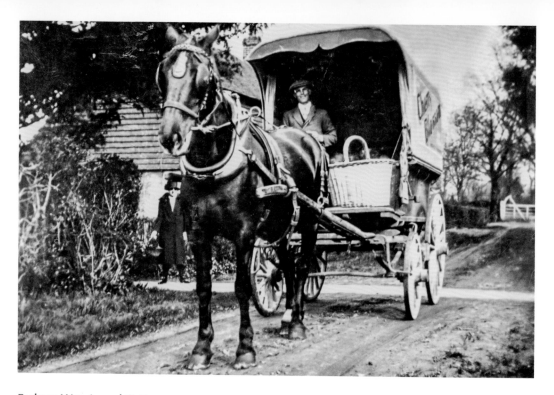

**Ersham Way, Laurel Cottage *c.* 1930**
Ersham Way was the tradesman's entrance to Ersham House, which stood where Ersham Park estate is today. The gate to the house is shown in the background and Nursery Path can be seen just behind Mr Matthews' horse and van, which is delivering bread from Catt's Mill to Laurel Cottage. Today, Laurel Cottage is surrounded by houses, and white vans deliver our online orders!

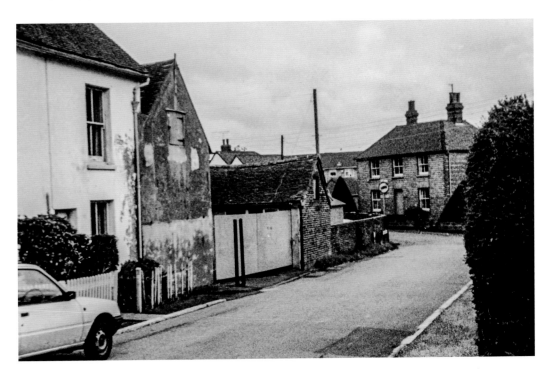

### Garfield Road, Slaughter House, 1980s

Vine's Slaughter House stood next to the terrace of white-painted houses on the corner of Garfield Road and Bellbanks Road and was demolished in the late 1990s. This was the view towards Yew Tree House in Bellbanks Road in the 1980s. Several attractive town houses were built on the site of the slaughter house and recently Yew Tree House has undergone refurbishment including having its chimney stacks removed.

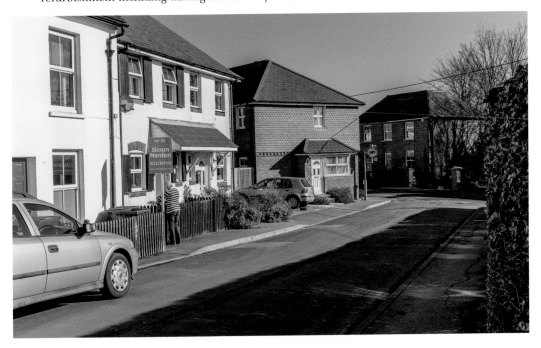

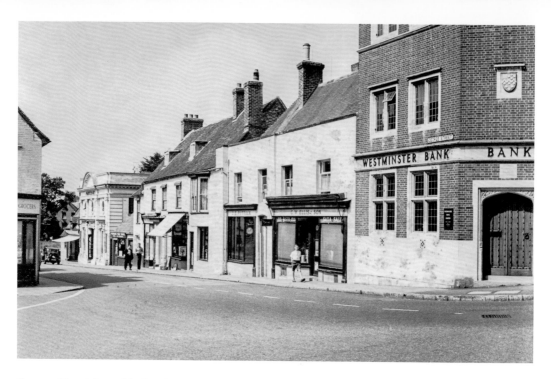

**George Street from Market Square,** *c.* 1960

Hailsham has lost a number of historically interesting buildings over the years, including the one housing Ellis's grocers shop and Puttock's ironmongers, next to the Westminster Bank. It was dismantled in 1963 and replaced by a new building which was designed to look very similar to the shop it replaced, and so, apart from the ugly street furniture, the modern-day scene does not look very different.

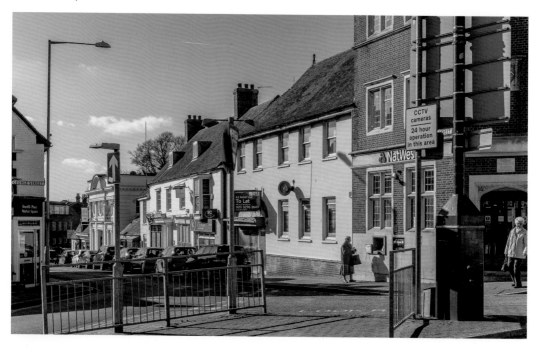

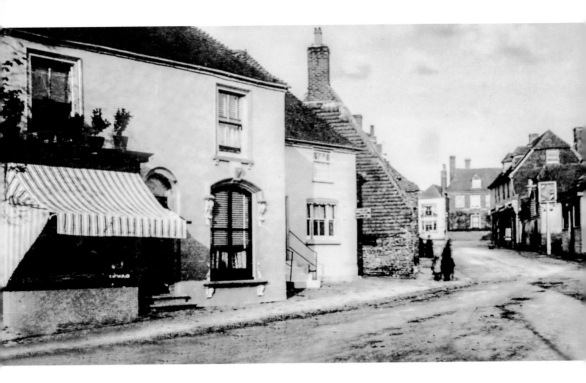

### George Street, *c.* 1880

Over the years, the house on the left has been a residence, a private school, a newspaper office and many different shops. The tile-hung building next door was a shoemakers and our lovely provincial cinema was built in the garden beyond. However, the buildings in Market Square and those on the right have changed over the years. The George Hotel, on the far right, was rebuilt following a fire on 29 May 2003 and is now a thriving and popular hostelry.

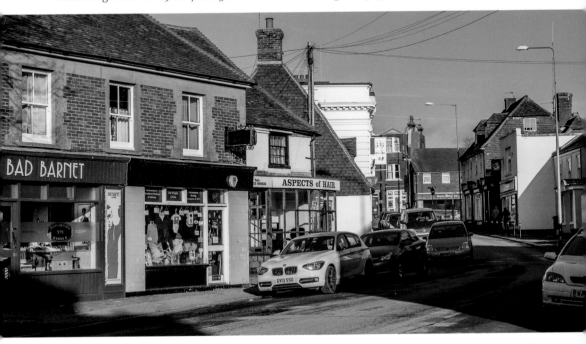

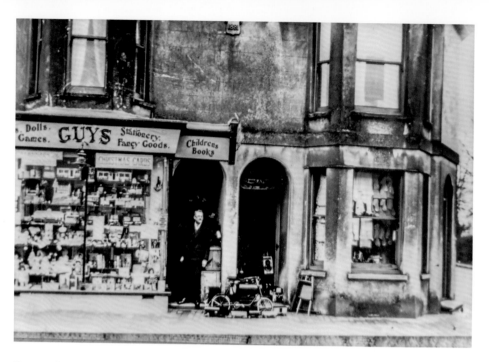

**George Street, Guys Shop, *c.* 1910**

This shop has always held a fascination for children, even when it became Chetwynds as we remember it as children in the fifties. The train set that ran around the window display at Christmas always attracted a crowd watching from the pavement. The shops became a sports shop by the 1980s, which was then converted to offices in 1985. Today, called Prospects House, it is occupied by the East Sussex Association for the Blind – another building that has had its chimneys removed.

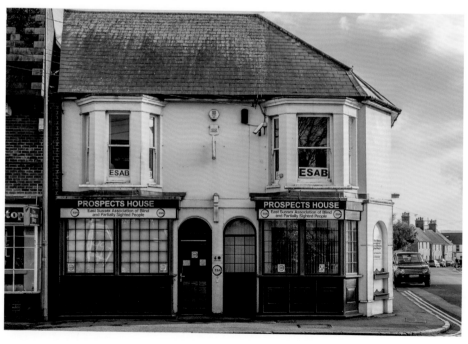

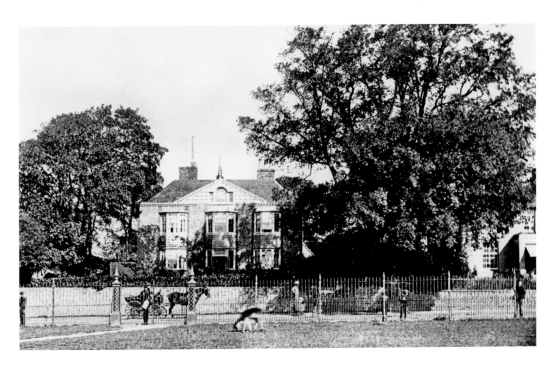

**George Street, Cortlandt from the Deer Paddock**

Cortlandt, built in 1793, was originally called Newhouse. William Strickland, the owner in the late nineteenth century, renamed it in honour of a previous resident, Philip van Cortlandt, who was barrack master in Hailsham during the Napoleonic Wars. The building has been extended over the years and was also used as district council offices. Strickland kept deer in the Deer Paddock opposite, which was developed in the 1960s as River Board offices and is now the police station.

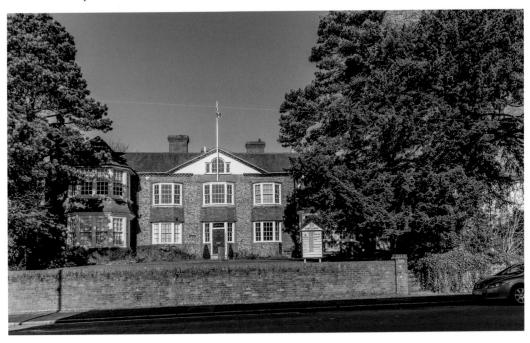

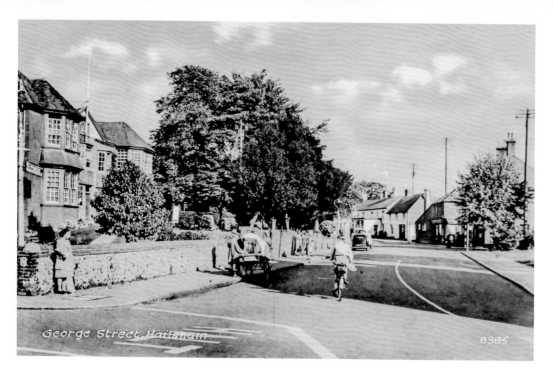

**George Street from North Street, *c.* 1955**
George Street had two-way traffic, and the stop sign for vehicles driving out of North Street was well out into the carriageway so that drivers could see around the Terminus Hotel. Mr Spiers, with his fish cart, is stationed in his usual spot – the last street seller in the town. What a difference today, as this is one of the town's busiest junctions. The lovely flint wall in front of Courtlandt has been replaced by brick after becoming unsafe.

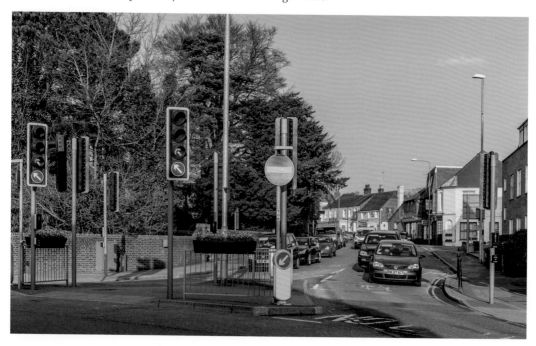

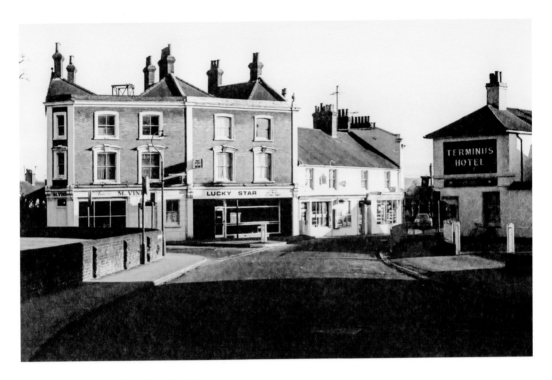

**George Street/Station Road, c. 1970**

The buildings at the corner of Station Road and George Street with their attractive red brick, contrasted with the smaller white-painted Taylor's bakery and cafe. The Lucky Star is still serving Chinese takeaway food today, but Mr Vine's butcher shop has been converted into a tattoo parlour. An extra shop was added next door in 2010 and the Terminus Hotel opposite has become a furniture showroom.

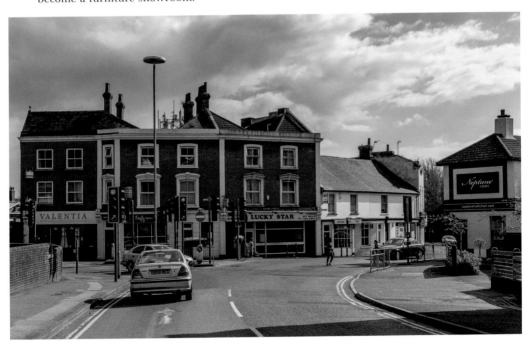

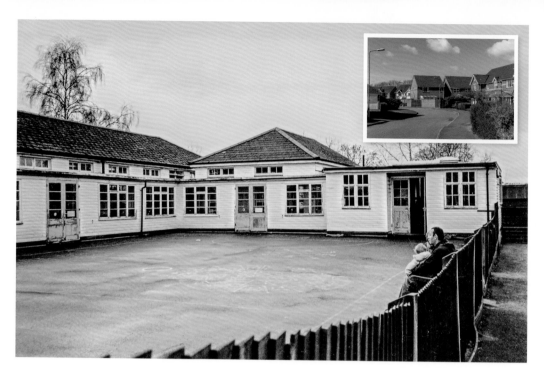

Grovelands Road, Grovelands School, *c.* 1990
The school was built in 1934 with an intended life of only ten years, but a new brick-built wing was added in the sixties and it became a large primary, taking infants as well. The wooden building was past its useful life when, in 1996, a new school (shown below) was built in the playing fields next door, with its entrance from Dunbar Drive. The old school was demolished and Cameron Close (inset) was built on the site.

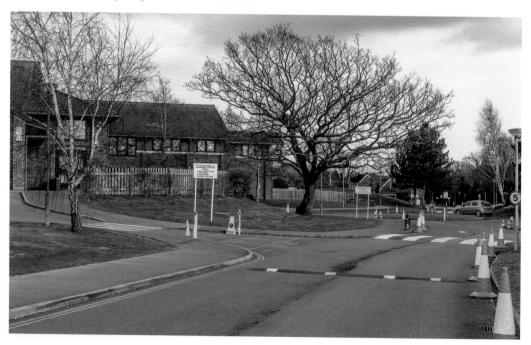

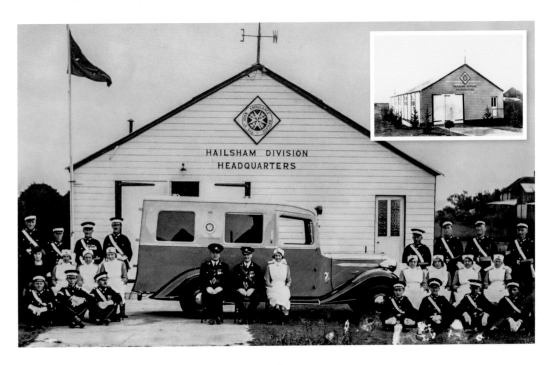

**Grovelands Road, St John's Ambulance Headquarters, 1939**
The second ambulance given by Donald Jarvis to the Hailsham Division St John's Ambulance Brigade is shown outside the headquarters in Grovelands Road after its formal presentation in 1939. The headquarters, which was also given by Mr Jarvis, was opened by Lord Hailsham in September 1933 (see inset), but it was demolished in 2010 and replaced by two chalet bungalows. In the modern-day view, one of the entrances to the new Grovelands School can also be seen on the right.

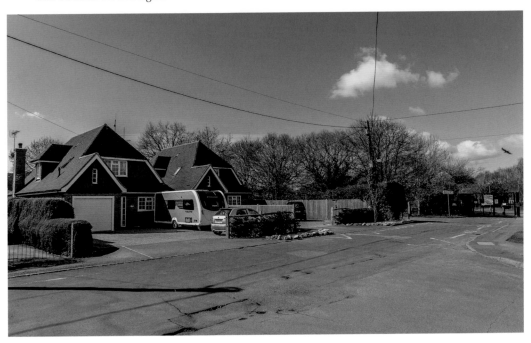

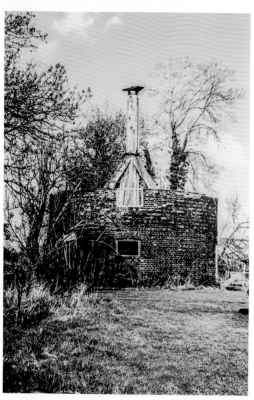

Harebeating Lane, Harebeating Mill, 1984
This mill was moved from the High Street in 1869 and was used commercially for many years, but it collapsed in a storm in 1934. The brick roundhouse with the mill post in the centre remained like this many years as a store before the Grade II-listed building was converted into a uniquely designed property in 2006.

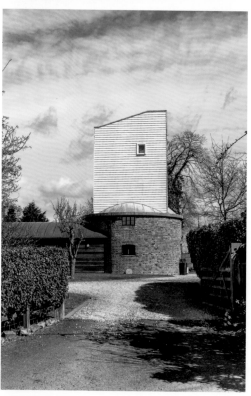

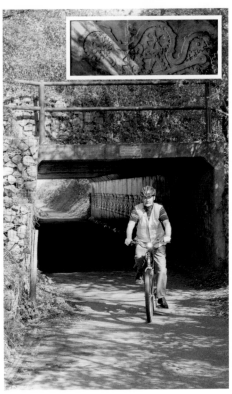

**Hawks Road, Railway Bridge, 1962**
Passenger trains to Hellingly and beyond were withdrawn in 1965. Nowadays, a far more leisurely journey can be taken on foot or by bicycle on the Cuckoo Trail, which has been built on the line of the old track. This bridge was originally filled in and buried when the track was removed as it was not considered safe for road traffic, but it was subsequently replaced by a concrete tunnel with attractive themed designs on the walls (see inset).

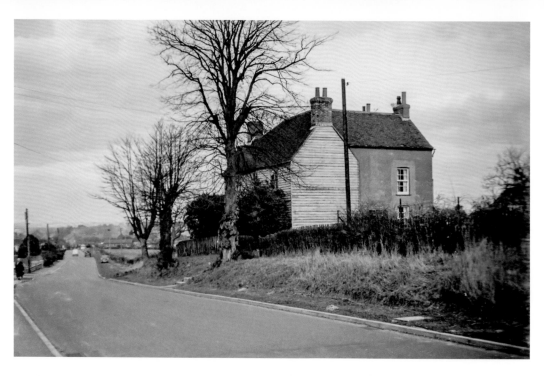

**Hawks Road, Hawks Farm House, *c.* 1965**
This substantial timber-clad house stood high on the bank and was a striking feature of Hawks Road. It was demolished in the sixties and the Howlett Drive housing development was built on the land behind. Somehow, the trees around the old house seem to have survived, but the open fields beyond have all been developed.

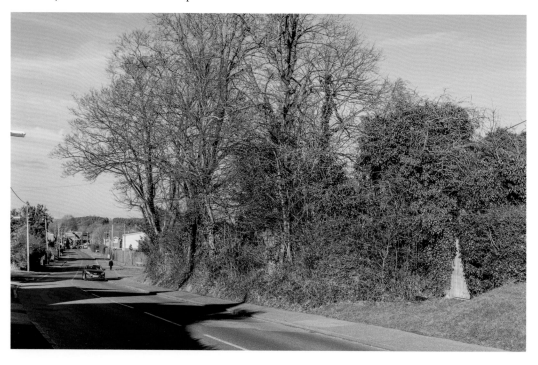

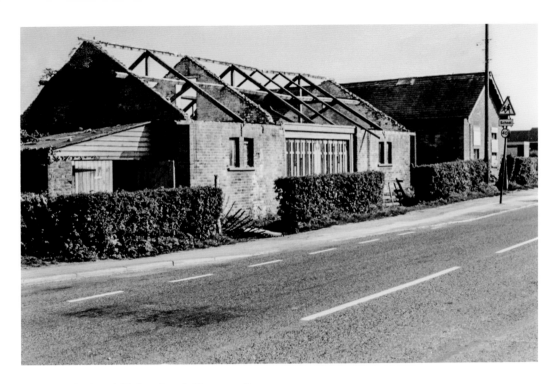

**Hawks Road, Union Coach House, 1982**

Hailsham Union Workhouse, built in 1835/36, stood at the end of Union Road and served eleven local parishes. The Board Room and coach house were built opposite in 1878. Houses replaced the workhouse after demolition in 1934 and Union Road changed its name to Hawks Road in the 1950s. The Board Room, which had been used as a bungalow, was converted into Union Corner Hall in 1982 and the coach house was demolished to make way for a car park.

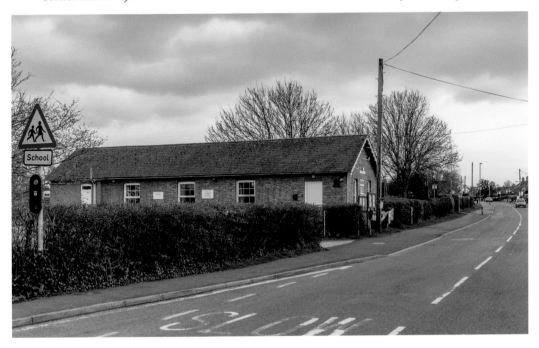

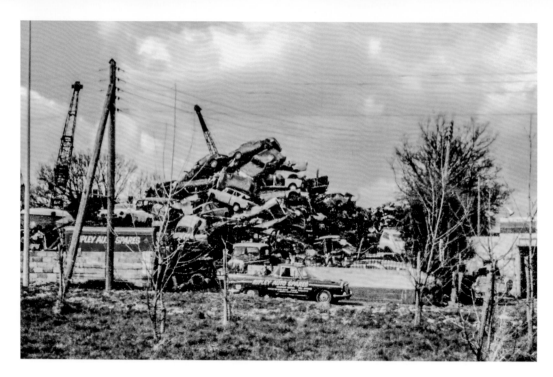

Hawkswood Road, Ripley's Scrap Yard, 1980

The scrap yard, next to Hawkswood Service Station, existed for many years and housing was built around it, especially during the 1960s. It had reached enormous proportions when this photograph was taken, shortly before it was relocated in the Diplocks Industrial Estate on the other side of town. After the site was cleared, a new doctor's surgery was built and the garage forecourt extended.

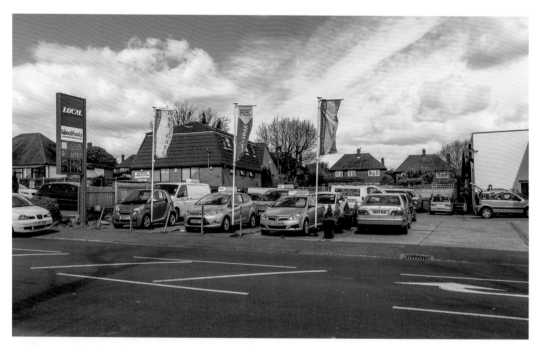

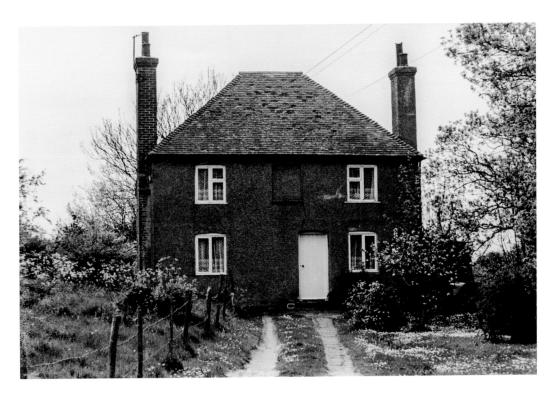

**Hempstead Lane, The Mount, 1989**

There has been a considerable amount of development in the Hempstead Lane area over the last few years, but this cottage seems to have escaped and still remains in its oasis of overgrown garden.

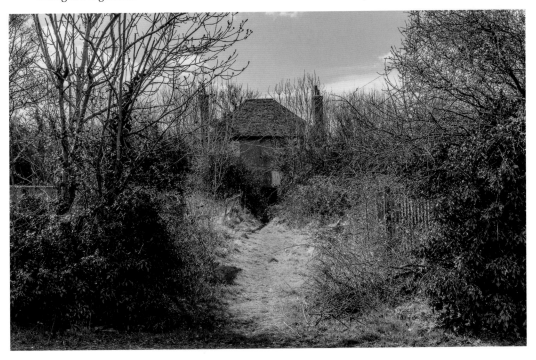

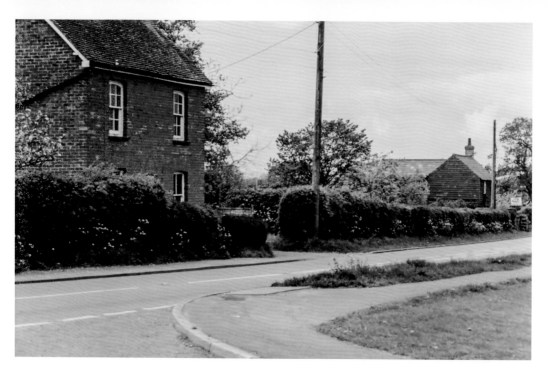

**Hempstead Lane, Green Fields and Tyle Cottage, 1989**

Next door to The Mount was Green Fields, which was demolished in the early 1990s and ten detached houses built. The green fields surrounding the property are definitely no longer green as this is one of the areas of town that has seen extraordinary development. Tyle Cottage, the next property along, still stands, with another small development being built around it. However, work seems to have stopped on this for the time being.

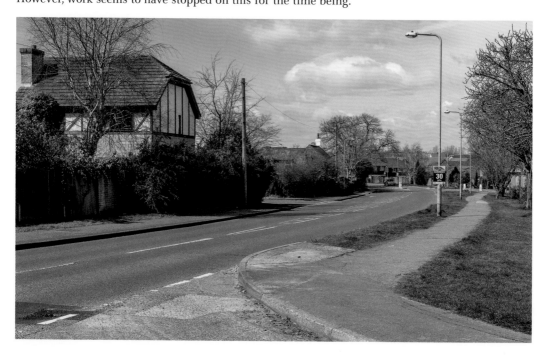

**High Street, Searle's Carpet Shop and The Grenadier Hotel,** 2000
Reg Searle, who lived in Summerheath House on the left, owned the carpet shop and a large haberdashery further down the High Street. In 2007, the carpet shop and house were demolished and replaced by a large supermarket with three self-contained shops attached. The Grenadier Hotel was built in the early 1800s, as a beerhouse for the large Napoleonic Barracks that occupied the Common in London Road beyond.

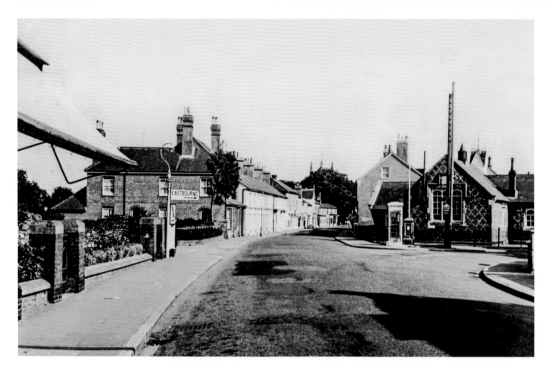

## High Street and Infants' School, *c.* 1958

The High Street is devoid of traffic and there is little street furniture spoiling the 1950s view. The infants' school, built in 1862 (see inset), has a telephone box and postbox outside. Considerable changes were made in 1987 and the building has since been used as a carpet warehouse and an art gallery, but is now an Italian restaurant. The clock on the roof, sadly no longer working, was originally on William Strickland's animal shelter in the Deer Paddock.

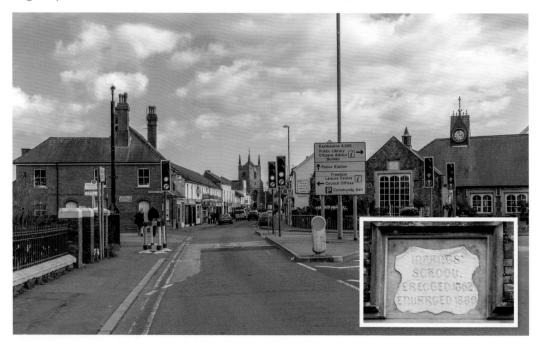

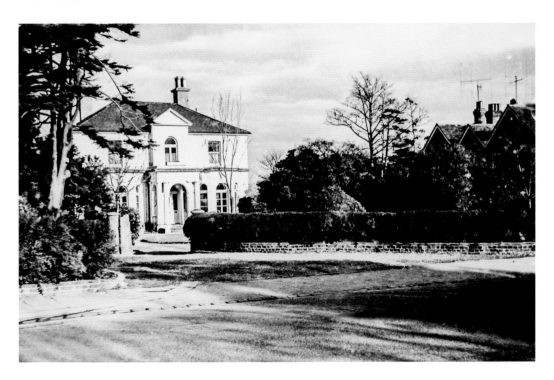

**High Street, St Wilfrid's, 1965**

This house was used as a doctor's surgery in the latter years of its life and the entrance to St Wilfrid's Green, a private unmade road, was on the left. Flats and houses were built on the site in 1970 and the access to St Wilfrid's Green and St Wilfrid's Court was changed to Vicarage Lane. Some of the houses and stables on the far right in Vicarage Lane were also demolished to make way for car parking.

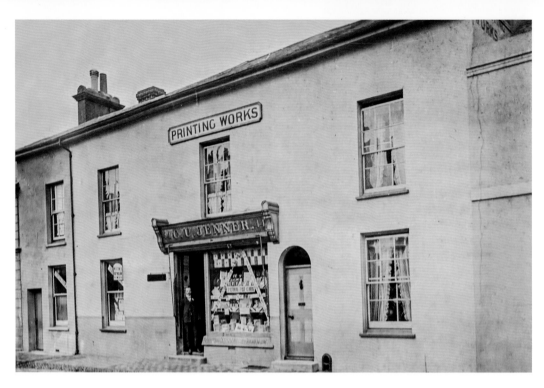

**High Street, Jenner's Printing Works, *c.* 1900**
Charles Underwood Jenner's printing works was in the High Street, and the business, taken over by the Bourne family, continued operating here until 1996. Little has changed, except the shop front has been enlarged and a smaller shop replaces the next door parlour.

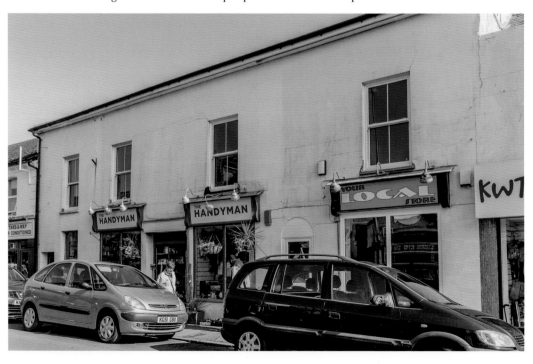

High Street, Co-operative Store, 1984

The Co-op store and Belle Vue Terrace, the block next door which housed the first telephone exchange in the early part of the twentieth century, were demolished in the eighties to make way for the Quintins Shopping Centre. The store moved into temporary accommodation in A. F. Smith's old workshop further down the High Street, (now St Mary's Walk) until the Quintins opened in November 1986. The Co-op finally moved out of Hailsham in 2011.

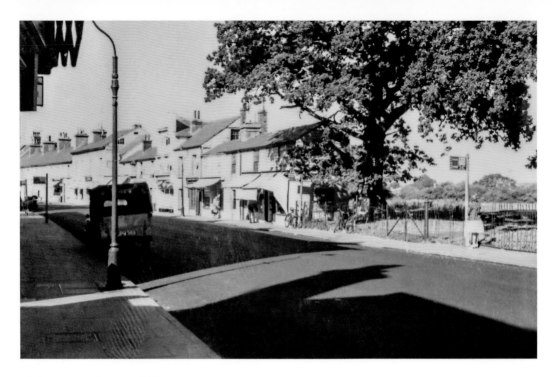

**High Street, Vicarage Field, *c.* 1960**

On the opposite side of the High Street to the Co-op was Vicarage Field, used to graze cattle and where the visiting fairs and circuses were held. The Vicarage Field shopping centre was built here in the mid-1960s (inset), which is when the short row of shops with the lower roofline were demolished. The modern view of the High Street shows that most of the chimneys have been removed from the buildings on this side of the road.

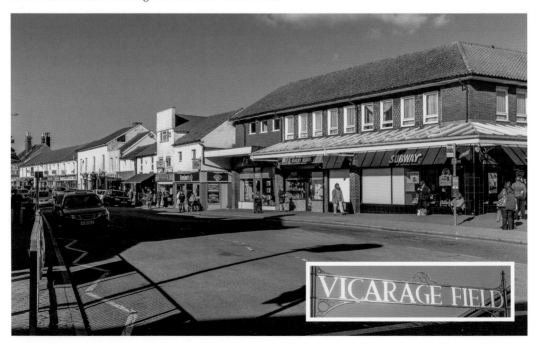

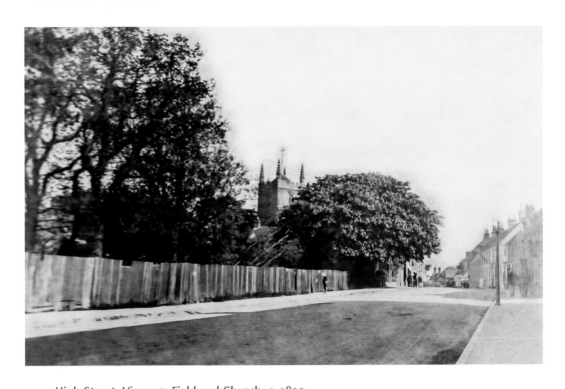

**High Street, Vicarage Field and Church, *c.* 1890**
This view of Vicarage Field is a bit of a puzzle, as the fence is wood and quite rough and uneven, but every other photograph that we have seen shows iron railings. Perhaps it was erected as a temporary measure to hide something or whilst the railings were being repaired. Today, the view to the church is much more open, although the chestnut tree still dominates the area beside the war memorial.

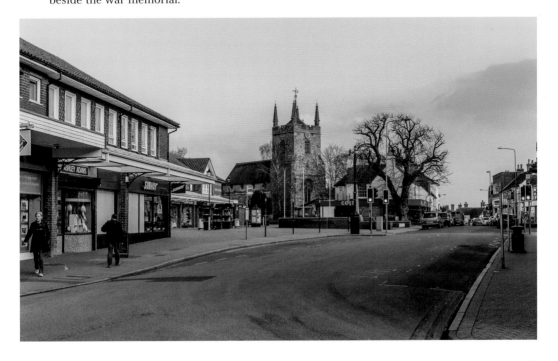

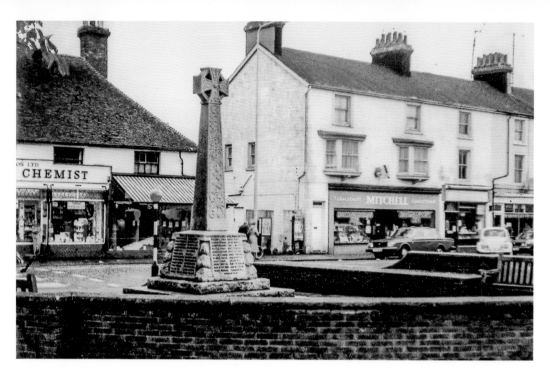

**High Street from the War Memorial, *c.* 1981**

Mitchell's tobacconist and confectioner was one of the last of these shops in the town. In the eighties the pedestrian crossing was in a slightly different place and the war memorial has since had planters built into the walls and flagpoles added. The Quintins Shopping Centre, named after Quintin Hogg, Baron Hailsham of St Marleybone, now stands on the opposite side of the High Street.

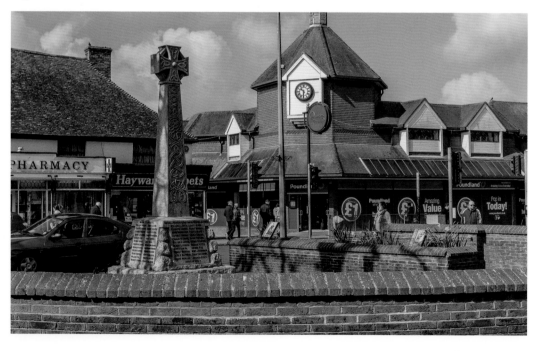

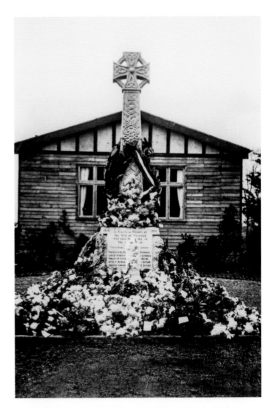

**High Street, War Memorial, 1920**

The memorial was unveiled on 28 November 1920 and was originally erected to honour those from Hailsham whose lives were lost in the First World War. The Comrades Club hall behind was demolished in the 1960s and replaced by the Hailsham Club when the new shopping centre was built. The people of Hailsham continue to honour those who lost their lives in war and in November 2014 we remembered the centenary of the start of the First World War.

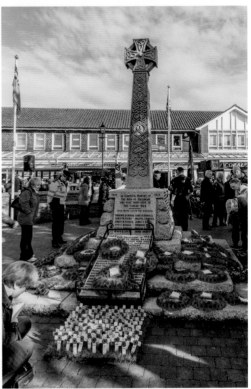

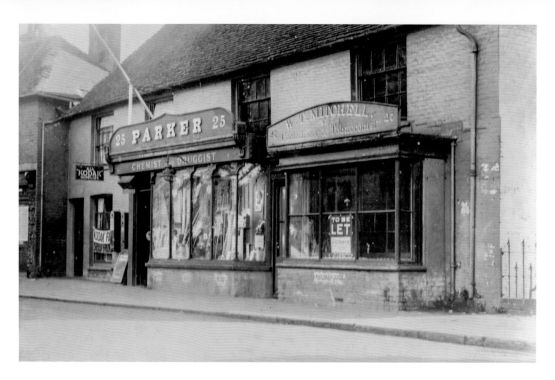

### High Street, Parkers Chemist, Early 1930s

Moore's greengrocer took over the old Mitchell's confectioners next door to the chemist shop, which is still there today but with a different owner. The building was considerably refurbished when the Quintins Shopping Centre was built, and some old ovens were found. The shop became a carpet store and makes an attractive entrance to the shopping centre.

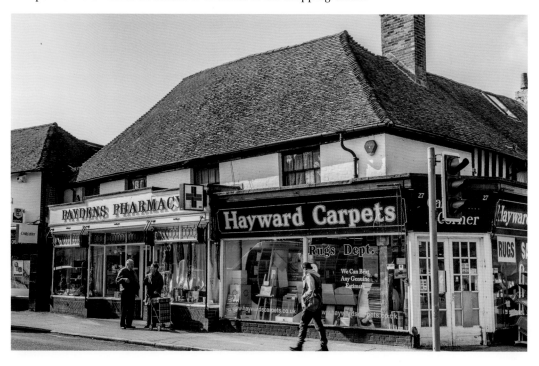

**No. 26 High Street, *c.* 1925**

Originally known as 'The Willows', this was, for some years in the nineteenth and early twentieth centuries, home to one of the local doctors. The house, with its integral garage, has been converted into shops and since the fifties has been home to Boots the Chemist, Stricklands and Tendring garden merchants and is now a barbers, an antiques centre and a coffee shop.

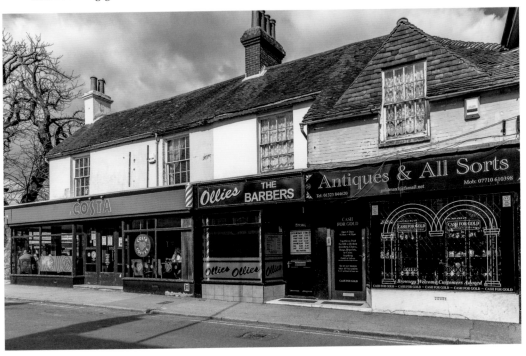

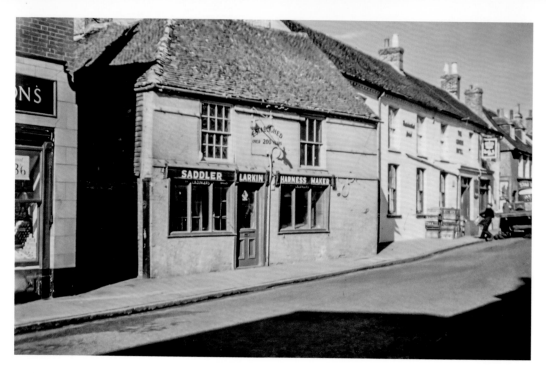

High Street, Larkins, *c.* 1955

Thomas Burfield started rope-making in Hailsham in 1807 and this shop, with a rope walk behind it, was part of his property. It later became Larkin's, a saddler and harness maker. The building stuck out into the High Street, which had two-way traffic, and indiscriminate parking caused horrendous traffic jams. It was demolished in 1956 to make way for a new Woolworth store, and the store became Iceland after Woolworths foundered in 2008.

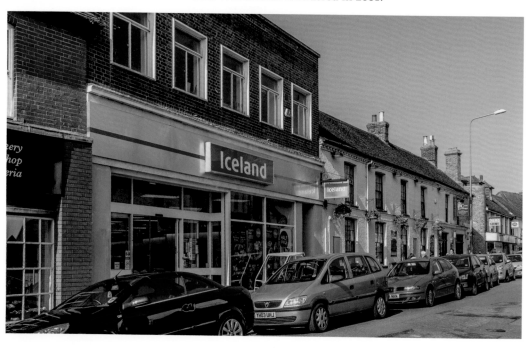

**High Street, Kerridges Shop and A. F. Smiths Garage, *c.* 1935**
Kerridges was a furniture and antique store, trading for most of the twentieth century. In 1935 they were visited by Queen Mary, who bought antiques, it is said, for Buckingham Palace. When Kerridges closed, the premises were split into three separate shops. A. F. Smith's garage further along the High Street later became the hardware department for the main shop opposite. St Mary's Walk has now been built on the garage site.

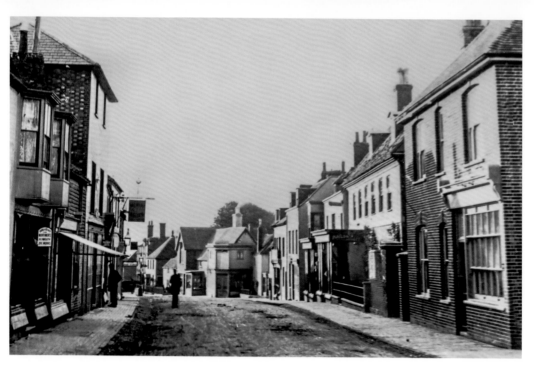

**High Street, Looking toward Market Square, *c.* 1880**
Most of the buildings at this end of the High Street, except for the bank on the corner, have not changed very much over the years, but have just had modern shop-fronts added. The brick pavements have now been tarmacked and the tea house in the distant Market Square no longer exists.

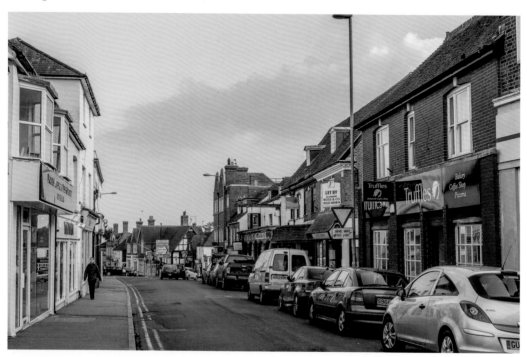

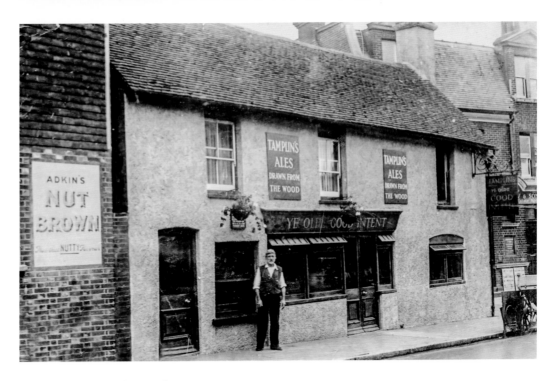

**High Street, The Good Intent, *c*. 1930**
One of the treasures of the High Street, this building is thought to be of seventeenth-century origin. Like many pubs, it has had a number of different names over the years, including The Conquering Hero, the Jolly Sailor, and finally The Good Intent. It closed in 1957, and reopened in the 1960s as The Homely Maid china shop before becoming once again a place of refreshment.

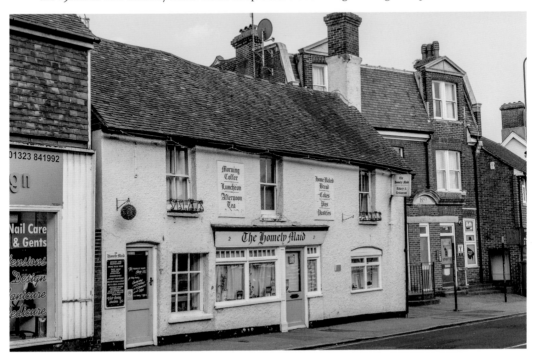

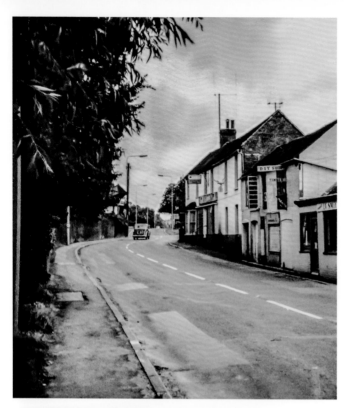

Horsebridge, Shops, *c.* 1975
This small parade of
shops on the road through
Horsebridge, was popular
with shoppers before the
advent of the supermarkets
in the town. The largest, on
the corner of London Road,
was Central Stores and the
end one was a butchers.
The shop in between was
variously a flower shop, DIY
store and window suppliers.
They were gradually
demolished in the late
seventies and early eighties,
with the butchers remaining
by itself until it too finally
succumbed to the developer.

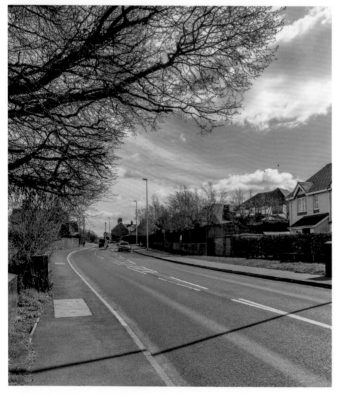

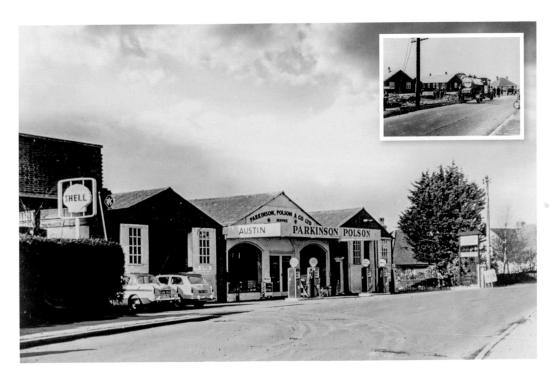

**London Road, Parkinson Polson Garage, 1965**

In the 1920s, two wooden buildings from Summerdown Camp in Eastbourne were moved to this site to be used as a rest home, but they were later incorporated into a garage and used as its offices and stores. They were removed when the garage underwent a major development, which included a new showroom setback from the road and large forecourt (see inset). The garage was demolished in 2010 to make way for retirement flats.

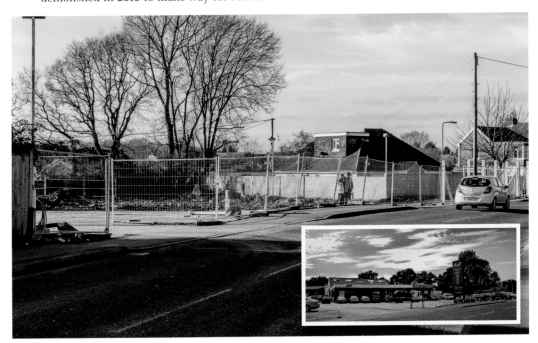

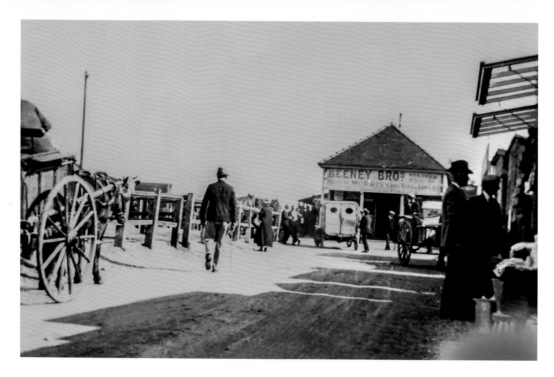

**Market Street, Hailsham Market, *c.* 1935**

Hailsham has been a market town since 1252, with a fortnightly livestock market held in the High Street and adjoining areas – quite a messy experience one would imagine! In 1868 the market moved to its present site. The location in the older photograph is immediately recognisable, as the central building is now a café. Beeney Bros, on the advertisement hoarding, were motor engineers and Morris agents, with premises at Sturton Place beside the Terminus Hotel.

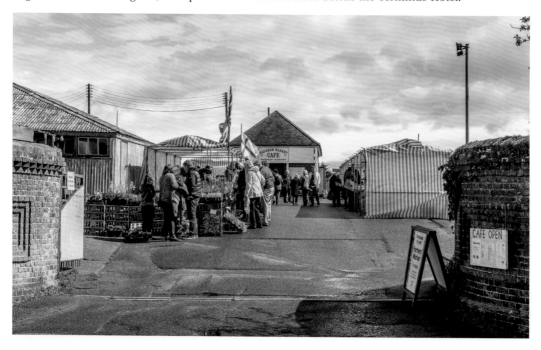

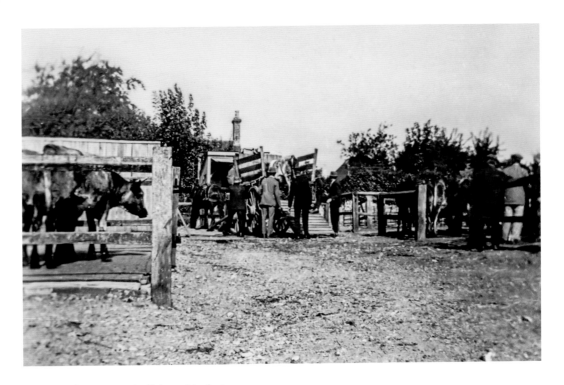

**Market Street, Hailsham Market, _c._ 1935**
Cattle lorries did exist in the thirties but this farmer had his own solution. Before the advent of motor transport it was usual for cattle to be herded along the public highway, and for longer distances they could be shipped by train. There were cattle pens at Hailsham station for holding livestock on their way to and from the Market. Today Hailsham is the only remaining livestock market in Sussex, and more sophisticated transport methods are required.

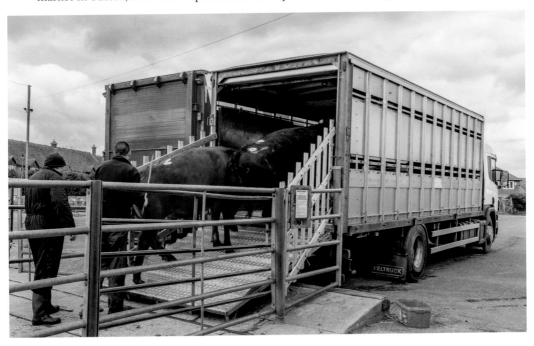

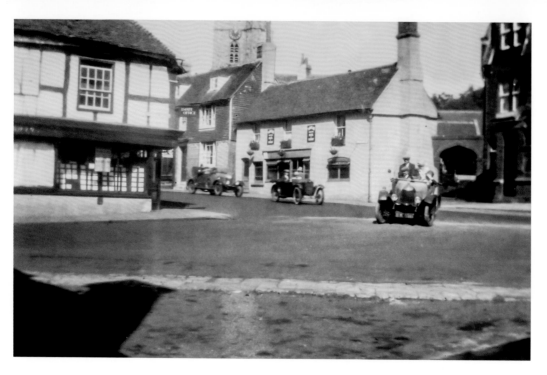

Market Square, *c.* 1932

It may have been confusing for the occasional thirties motorist, as there seem to be no priority markings or bollards at what is now a busy junction. Otherwise, apart from the disappearance of the shop on the left, and the conversion of No. 4 High Street into a nail bar, the visible buildings are unchanged.

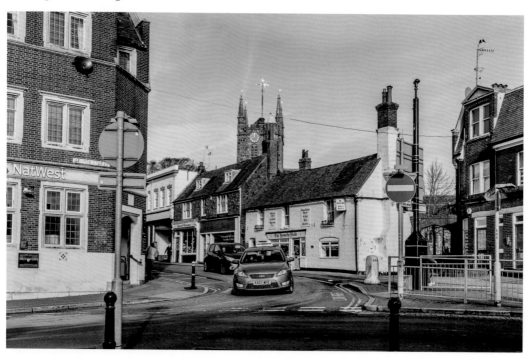

**Market Square, St Mary's, 1937**

Hailsham has not always been particularly good at preserving its ancient buildings and St Mary's, shown here being demolished in 1937, was a building of some distinction and considerable age, the date 1583 being found carved into a beam. The site remained vacant for some years and during the Second World War accommodated some National Fire Service huts. These were destroyed in February 1943 by the German bomb whose blast also shattered most of the church windows.

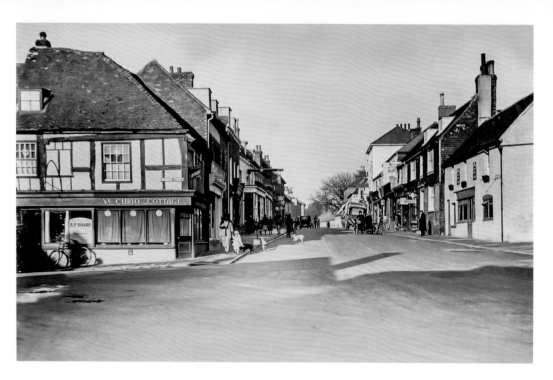

**Market Square, Looking Towards High Street,** *c.* 1932

A quiet day in 1930s Hailsham: the building on the corner of George Street was undoubtedly of great age, possibly fifteenth century but nevertheless in 1935 it was demolished and the Westminster Bank building erected, dominating the view. There is no moving traffic and people and animals are able to make their leisurely way down the High Street. This was called Proclamation Corner, probably because important news and notices were proclaimed to the townsfolk here.

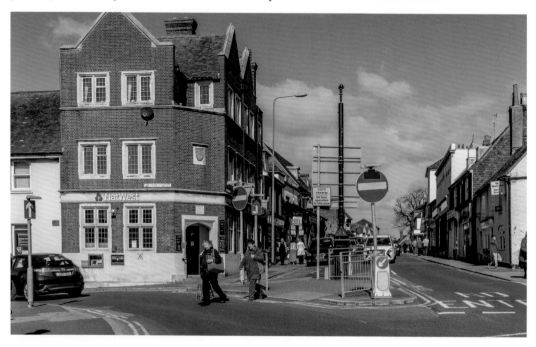

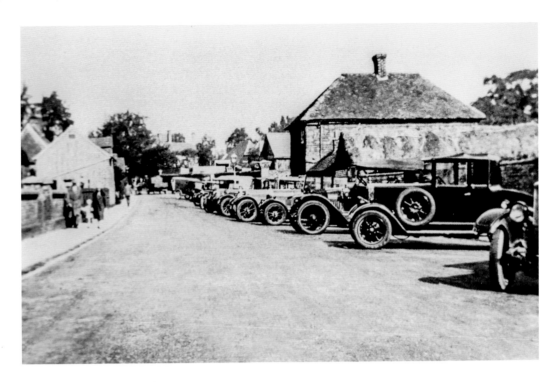

**Market Street, Market Day, *c.* 1935**
Even in the 1930s Hailsham was one of the busiest markets in Sussex and it attracted farmers and dealers from a wide area. Lack of passing vehicles means they have been able to park their cars end-on to the kerb, thus maximising the space. Apart from the age of the vehicles, the major difference between the photos is the 1960s development of Southerden Close on the left and the replacement roof on the thatched outbuilding in the cottage garden.

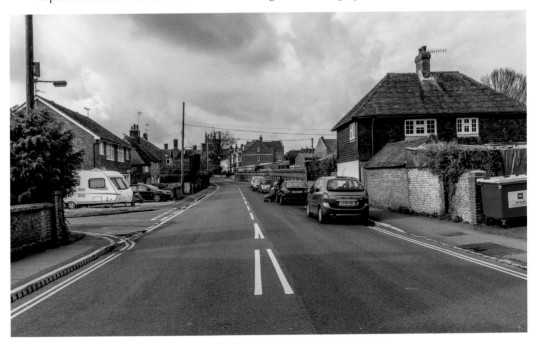

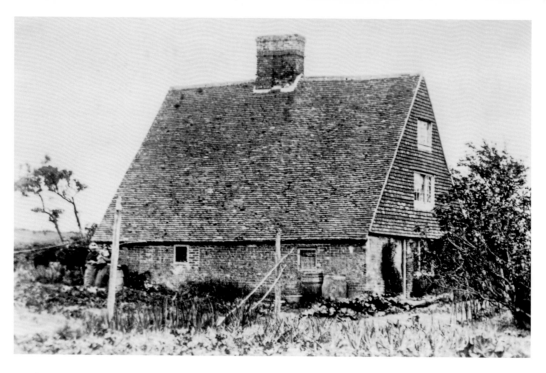

**Market Street, Hencoop Cottage, *c.* 1890**

'The Hencoop', named because of the style in which it was built, was situated in the grounds of Market Nurseries. The exact date of the building is not known, but is believed to have been the early 1700s. It was occupied by members of the same family from 1896 until 1975 and was then vacant until its demolition, along with The Nursery, in 1986 to make way for The Stiles.

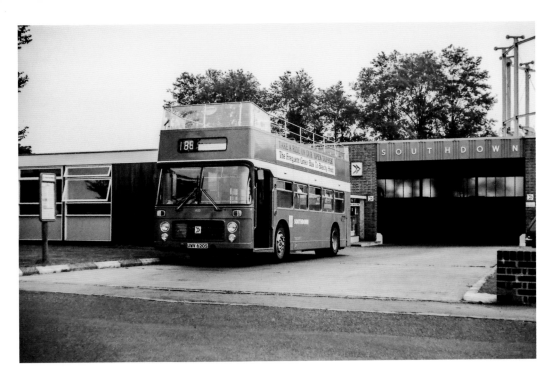

## Mill Road, Southdown Bus Garage, 1986

The main entrance to the bus garage was in Mill Road, with the enquiry and booking office on the left. The bus in the picture is a Bristol VRT convertible, open top for seaside use in summer, and a hard top for winter. Southdown Motor Services was founded in 1915 and it is good to know that the name has been perpetuated in Southdown Court, which, coincidentally, also has wonderful views of the South Downs.

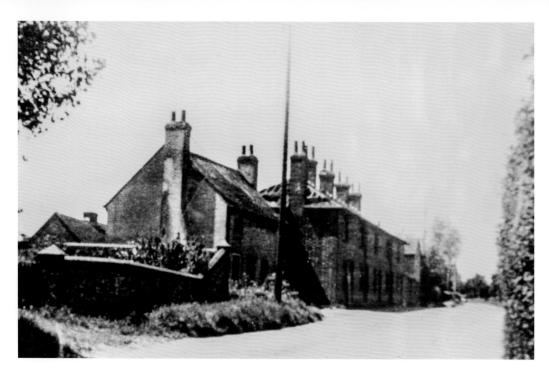

**Mill Road, Millwalk Cottages, *c.* 1954**

One of several rope walks in Hailsham, where outworkers made rope and string by hand, was in Mill Road on the town side of these cottages. This was the Duke of Devonshire's land, which extended from the market and around much of south Hailsham. Long after the ropewalk went out of use, the land was sold off in plots by auction in the early 1900s. The rope-workers' cottages were eventually demolished in the fifties and replaced by bungalows.

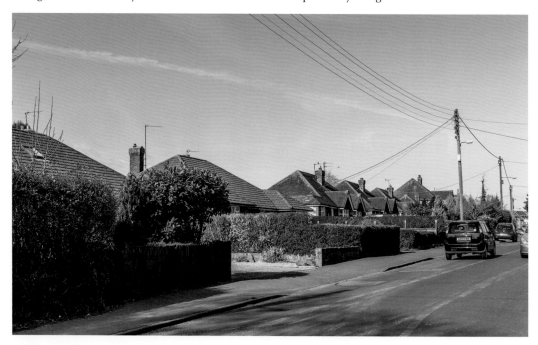

**Mill Road, The Acorns, February 1998**
This cottage was built in the late nineteenth century in the orchard next to Millwalk Cottages by Mr John Carey Pitcher, whose initials appeared on a large plaque above the door, and was demolished in 1998. Originally a favourite place for local youngsters to go scrumping apples, The Acorns private development now stands on the site.

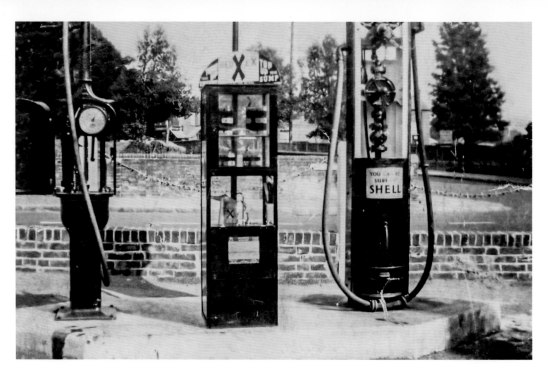

**North Street, Terminus Garage (Bucks)**

It seems hard to believe now, but before the completion of the Hailsham bypass at the beginning of the Second World War, the main London–Eastbourne road passed through the centre of Hailsham. A planning document of 1931 describes the route as 'tortuous and circuitous'. The A22 route passed through North Street, so this was a good place for a filling station.

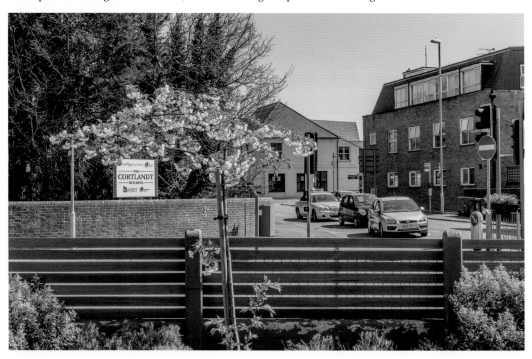

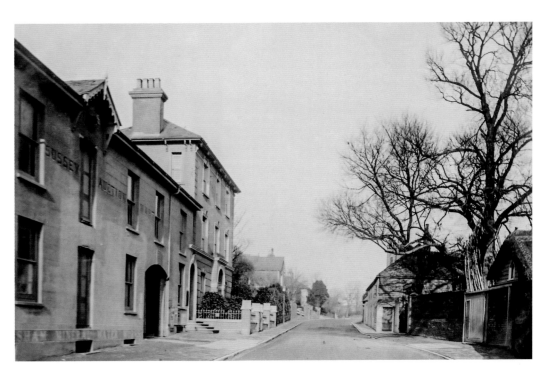

**North Street, Hailsham Mineral Water Works, *c.* 1910**

North Street is probably the most redeveloped road in the town centre; however the buildings on the left still remain. From around 1903 to around 1916 Hailsham Mineral Water Works, proprietor George G. Guy, was manufacturing ginger beer and no doubt other fizzy drinks here. The cottages on the right were demolished in 1986/67 when the road was widened and Quintins car park constructed.

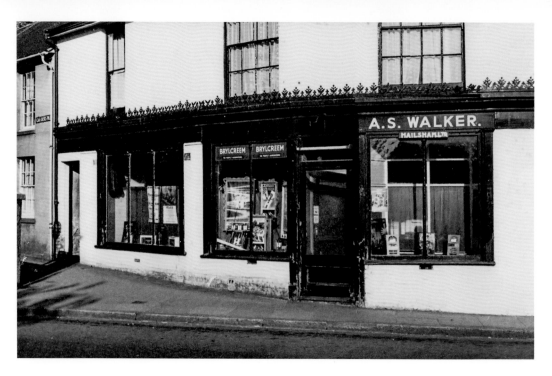

### North Street, Carriers Path, 1970

Carriers Path was so called because it led to the carriers' yard in the High Street. Before the age of railways and motor vehicles, carriers' wagons regularly transported goods between local towns and even as far as London. Although the 1970 photograph shows two separate shops, entry was through a shared outer door. On the right was A. S. Walker's coal merchant's office and to the left Charlie Hudson's barber shop complete with Brylcreem adverts in the windows.

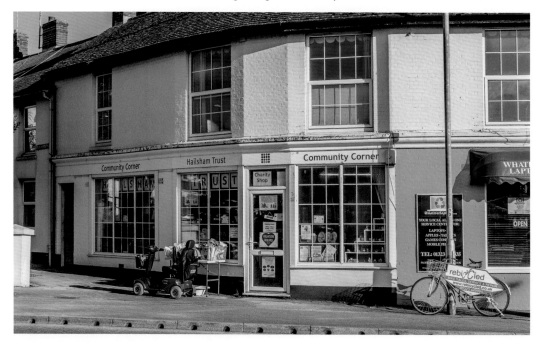

**North Street, White House School, May 2000**
White House School was built in 1964 and was so-called because the land had been given by a prominent local businessman Harry White specifically for the construction of a new school. With the redevelopment of North Street a replacement school was built in Marshfoot Lane and the building shown here was demolished in 2008. The life-size bronze figure of a rope worker in the modern photograph pulling on three ropes celebrates the history of rope-making in Hailsham.

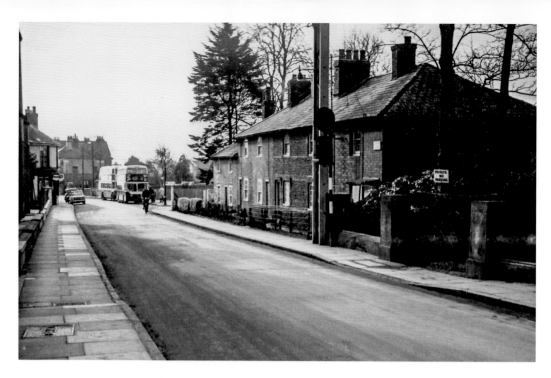

**North Street, Summerheath Cottages, 1965**

The whole area west of North Street was at one time known as Summerheath, and these cottages were quite likely built for farm labourers. Just visible, front right, is part of the boundary wall of The Laurels, which had been a military hospital during the First World War. The cottages and the Laurels would shortly be demolished, the Laurels site being made into a carpark. North Street was quite narrow, and one-way – quite different from the modern-day road.

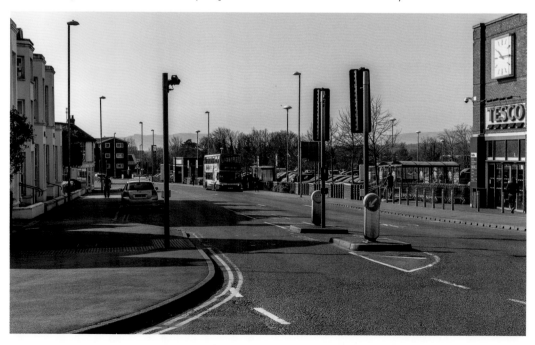

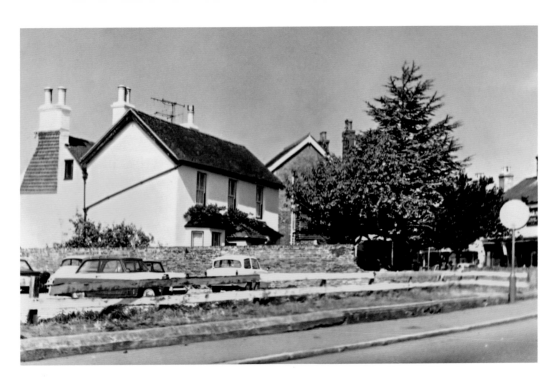

### North Street, Summerheath

Strictly speaking, this view is of buildings facing the High Street, but in the foreground is the car park on the site of the Laurels in North Street. Summerheath may at one time have been a farmhouse. It had an old walled garden with much mistletoe on the fruit trees and was for some time Doctor Burfield's surgery before being owned by Reg Searle, a prominent businessman in the town. It was demolished in 2007.

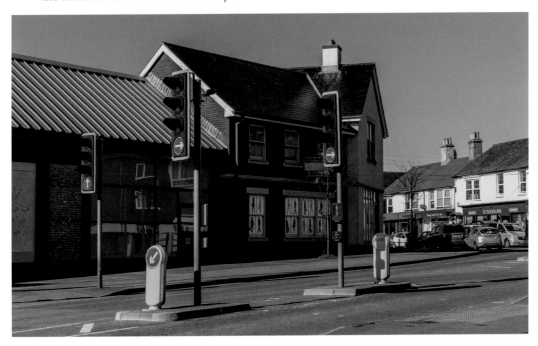

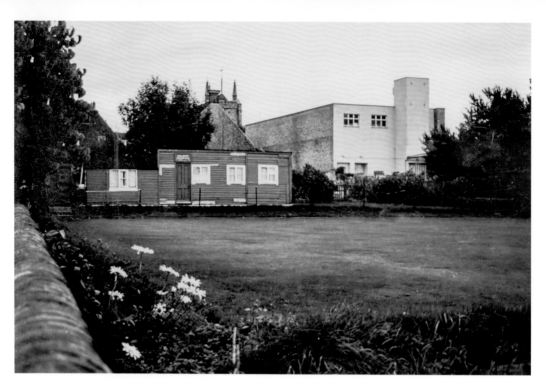

**North Street, Bowling Green, c. 1985**
This had been the green for Hailsham Bowling Club since its formation in 1923 – but not for much longer. In 1985 the land was required for the Quintins shopping centre car park, and a new green was provided for the Bowling Club behind the Leisure Centre in Vicarage Lane.

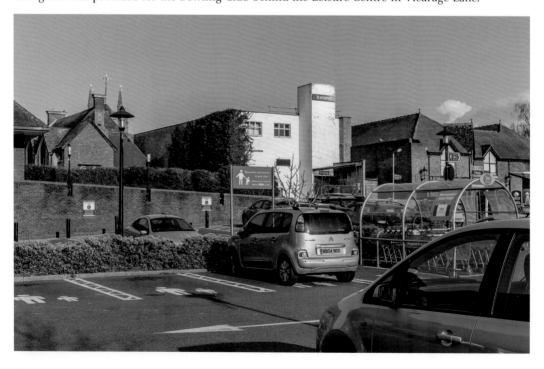

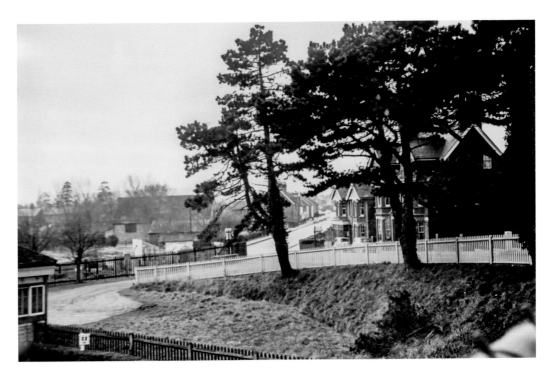

**South Road, from Railway Bridge, *c.* 1963**

Behind the signal box on the left was a gate onto the up platform, which was linked by a subway to the down platform and ticket office. The white milepost indicates the distance to Brighton is 22½ miles. Although the railway completely closed in 1968, the land was not cleared for development until 1980. Eventually the present car park was constructed, and in 1996 the bridge was substantially reinforced and the surrounding area landscaped, successfully retaining two of the pine trees.

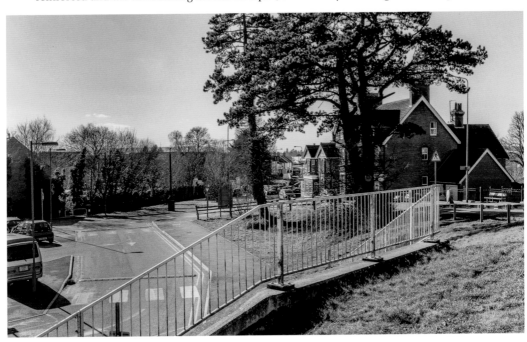

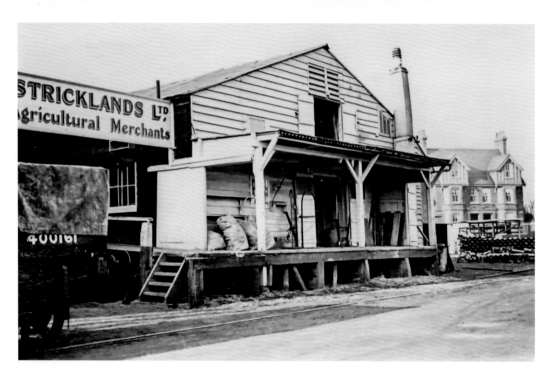

**South Road, Station Yard, Stricklands, 1930s**
Stricklands were seed merchants and suppliers of animal feedstuffs, and they shared this building with an egg packing station in the corner of the station yard. It was in the egg-packing station that a fire started one night in October 1945, and the whole building was destroyed. The site was left vacant as Stricklands moved to the far end of Station Road. The car park and part of Lindfield Drive now occupy this area.

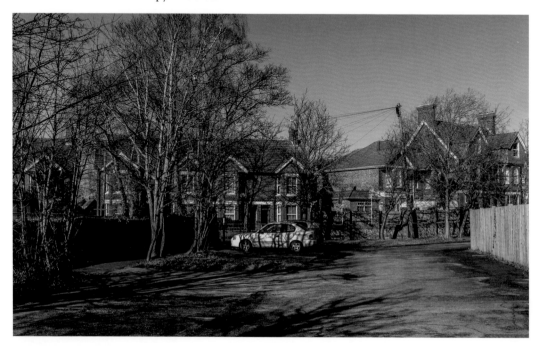

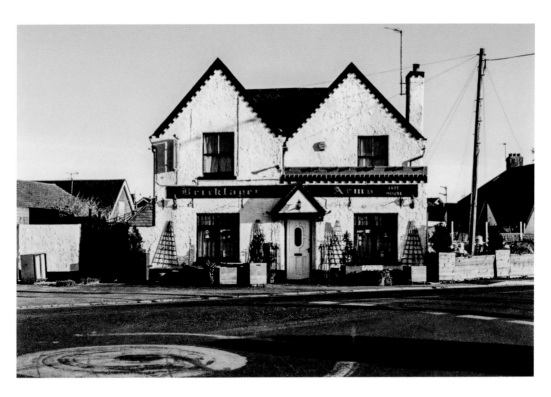

**South Road, Bricklayers Arms, 1996**
Strategically sited at the junction of Cemetery Road (later Ersham Road) and South Road and known affectionately as 'the Brickie', the Bricklayers Arms served beer for well over a century. It was demolished in 2009 and in 2012 flats were built and the site was named The Old Bricklayers.

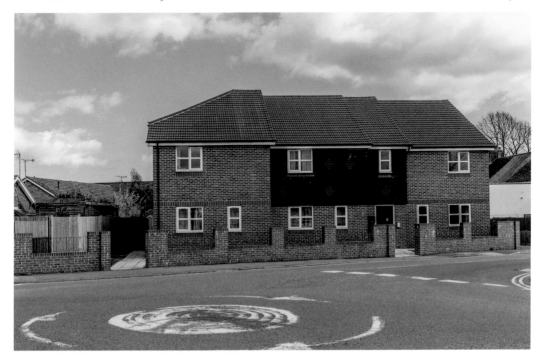

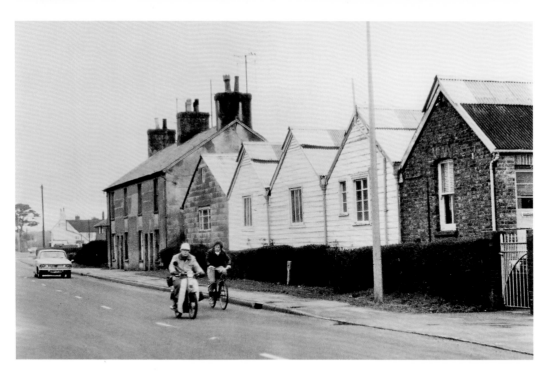

**South Road, Burfields, *c.* 1970**

Burfields and Green Bros were two major employers in nineteenth- and twentieth-century Hailsham, manufacturing rope, cord and similar products such as matting and even garden furniture. Many of Burfield's interesting buildings remain, but today most have been converted into retail units, and the rope-making operation has transferred to Marlow Ropes in new premises in Ropemaker Park.

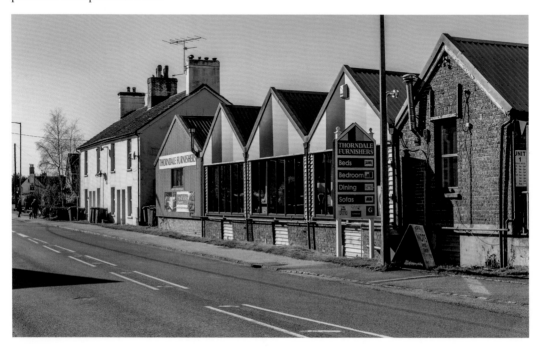

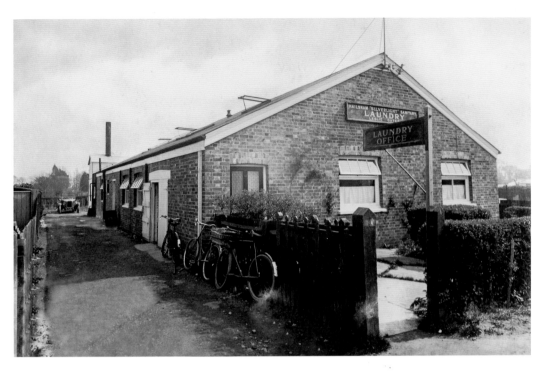

**South Road, Silverlight Laundry, 1950s**
Hailsham Silverlight Laundry was founded in the 1930s, long before the era of laundrettes and domestic washing machines and tumble driers, and many local people will have sent their washing here. The company was wound up in 1976, and in 1994 the site was redeveloped as South Close.

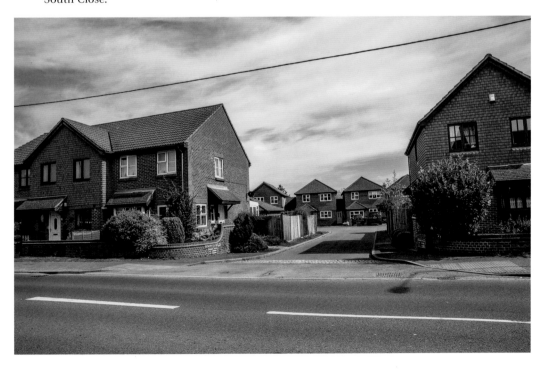

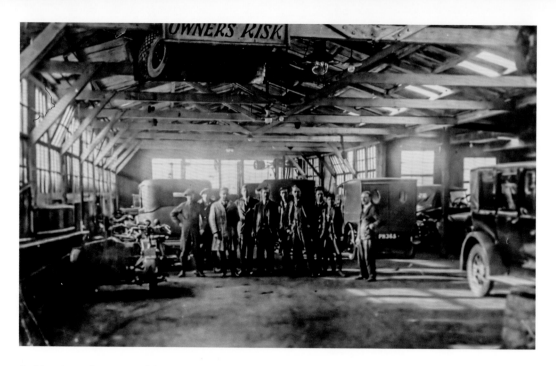

**St Mary's Walk, A. F. Smiths Garage, *c.* 1930**

Who would recognise the site of St Mary's Walk from the 1930s picture? A. F. Smith Ltd had premises on both sides of the High Street and in 1930 advertised as 'Ironmongers, builders' merchants, motor agents, dealers, engineers & haulage contractors, (depot South Road)'. The motor business seems to have ceased in the late thirties, and later use of the garage included cycle repairs and building tiled fireplaces. Demolished in 1989/90, it was replaced by this imaginative development of small shops.

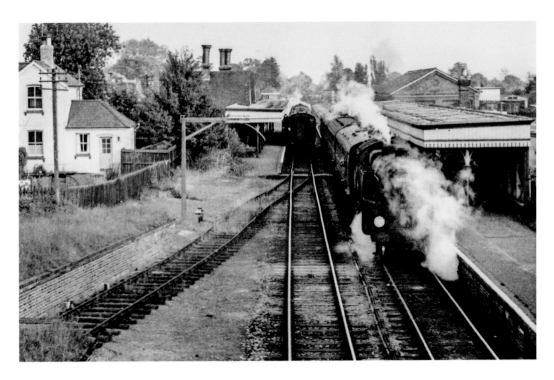

**Station Road, Railway Station from the Bridge, 1965**
At the up platform (right) a train is about to depart for Eridge and Tunbridge Wells, while the down train is going to Polegate and Eastbourne. This was a few days before the last steam trains, and the end of passenger trains from Hailsham northwards on Sunday 13 June. The only part of the station still remaining is the Station Master's white-painted house (left) and the railway line known as the Cuckoo Line has become the Cuckoo Trail (see inset).

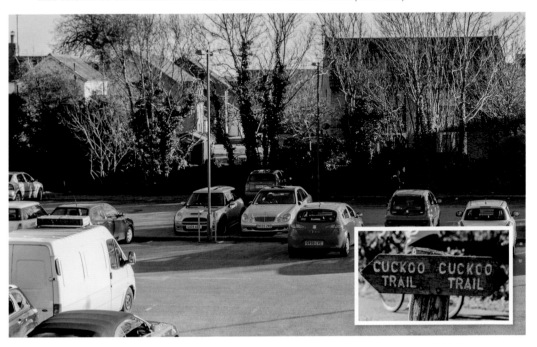

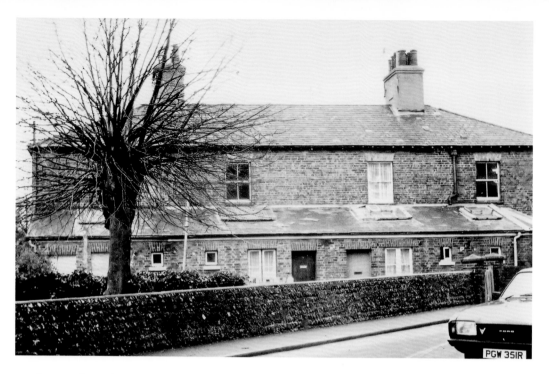

**Station Road, Station Cottages, 1970s**
This handsome block of four cottages was built for railway employees, in a corner of the station yard and they probably dated from 1849 when the railway first came to Hailsham. They were demolished in 1984 to make way for the South Road car park. The tree and the flint garden wall still remain, although the wall is a little overgrown.

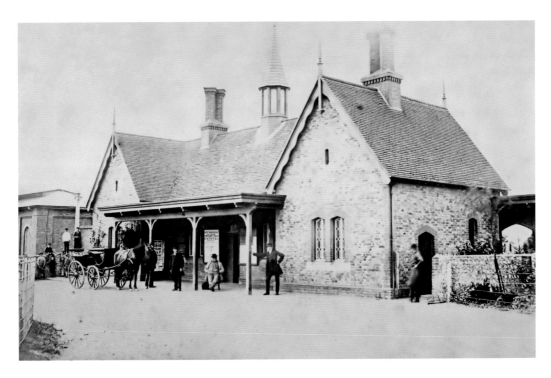

**Station Road, Railway Station, *c.* 1890**
This is how the station must have looked when the line to Polegate was opened in 1849. Near the traveller sitting down is the door to the booking office. At the far left of the photograph is the engine shed, which was mostly demolished in 1892, leaving only the wall which backed onto the down platform. Today all that remains of the station entrance is the small layby indicated by the curve in the granite kerbstones.

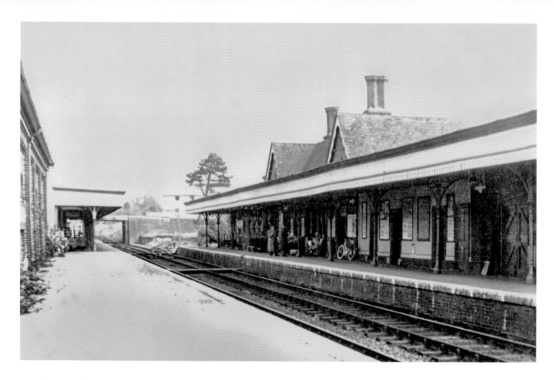

**Station Road, Railway Station Looking North, c. 1965**
Hailsham station had been built as a terminus, and only a single platform was needed – the one on the right side of the photograph. After 1880 when the line was extended, this became the down platform, and another platform and waiting room were built for northbound passengers. A bridge was also constructed to take road traffic across the line. After the line closure, this bridge was deemed unsafe and was supported by huge timbers (see inset) until rebuilt in 1996.

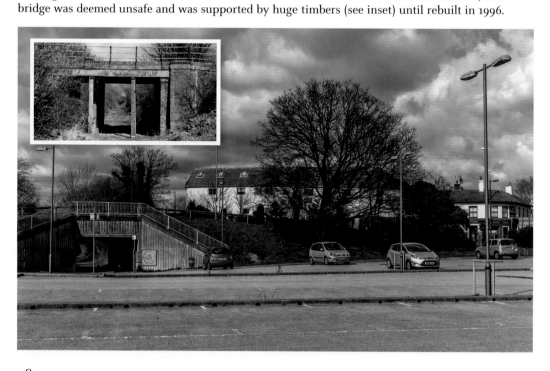

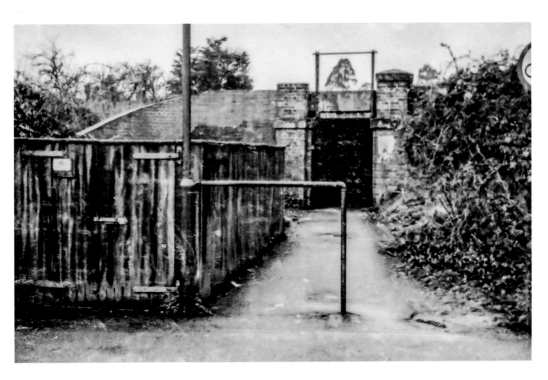

### Station Road, Nursery Path Tunnel Entrance, Early 1970s

Just south of the station the ground drops away and the railway ran on an embankment. Where it crossed Nursery Path a pedestrian underpass was constructed, and what fun it was as children to listen to the echo as you shouted and screamed through the tunnel! Today the ground has been levelled for the Lindfield Drive development and the echoes are just a distant memory.

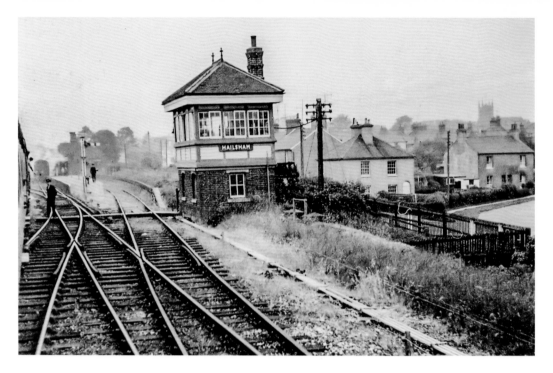

**Station Road, Signal Box and Bellbanks Road from Train, 1965**
This is the main Hailsham signal box and the signalman is waiting to receive the single-line staff from the fireman. Nursery Path emerged from the tunnel beside the fence where the cattle pen exit was originally. In the background can be seen the houses on the corner of Station Road and Bellbanks, with the church tower in the far distance. Lindfield Drive now follows the line of the railway track, but the inset shows the same view from Station Road.

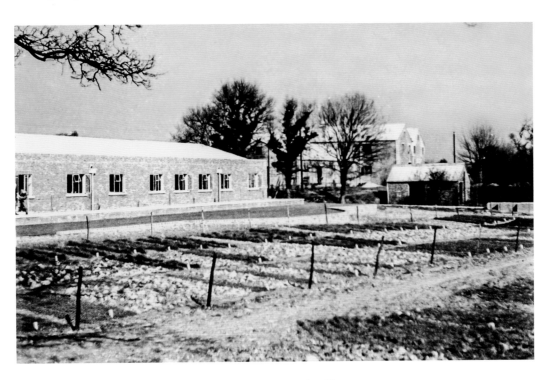

**Station Road, Stricklands, Seed Trial Gardens and Mill, 1950s**
After their granaries and offices in the station yard were destroyed by fire, Stricklands moved their operation to a site in Station Road where they already had a mill. As seedsmen, they tested seeds in the laboratory and in trial beds outside. The firm closed some years ago; the buildings were demolished and the seed beds overgrown. The area in front of the mill, a former brickyard, is now the Station Road Industrial Estate.

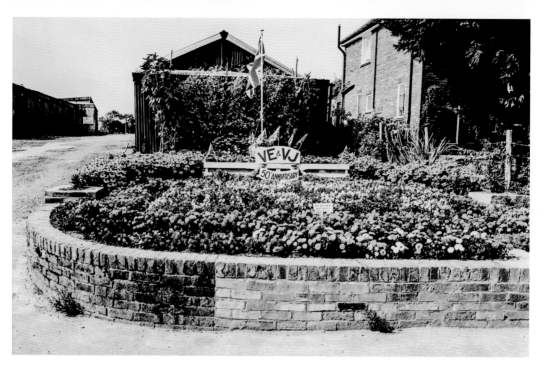

**Station Road, Wellers Garages and VE/VJ 50th Anniversary Garden, 1995**
These wooden buildings were let out to car owners in the area who did not have garages attached to their houses and in 1995 had a beautiful display commemorating VE/VJ day. The garages were demolished in 2008 and The Sidings development was built. It is interesting that this road name is one of the few references to the railway – others are Station Road, Terminus Place and The Railway Tavern. Although of course, The Cuckoo Trail is the railway's legacy.

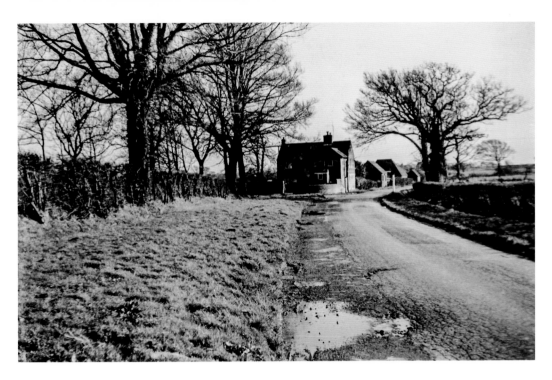

Station Road, The Swan Beerhouse, c. 1963

The Swan stood on the corner of Old Swan Lane and Station Road, and later became a private dwelling. The house was demolished sometime in the 1980s and the site remains vacant today. On the front left of the modern-day photograph is Swan Barn Road, which was where Holland's coal yard relocated in 1979 when the station was redeveloped.

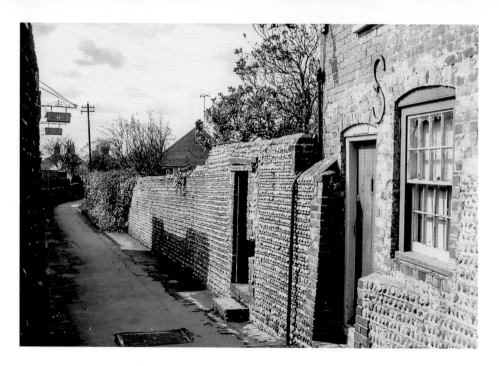

**Stoney Lane and Candle Cottage, *c.* 1975**

The magnificent flint wall on the left borders the yard behind Fleur de Lys, which until 1854 was the parish poorhouse. The wall was built with sea flints which the inmates dragged from Pevensey in handcarts. The projecting signs indicate Hailsham's first public conveniences, which were closed around 1980. Candle Cottage, believed to have been named because a previous occupier made candles there, stood empty and dilapidated for a number of years before being refurbished in the 1980s.

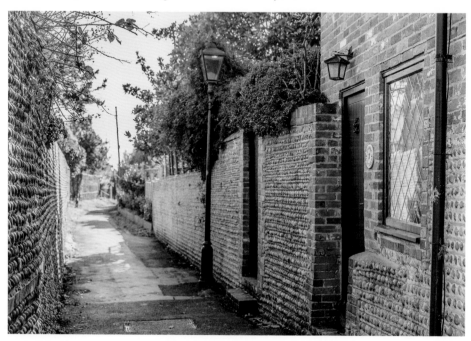

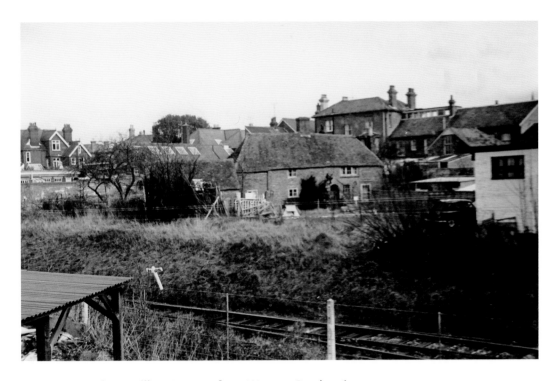

**Sturton Place, Willow Cottage, from Western Road, 1965.**
The official address of Willow Cottage was Station Road, which used to lead direct into Western Road at a spot still visible beside Bridgeside Surgery's car park. The northward extension of the railway in 1880 cut across the end of Station Road and the railway bridge was built to link Station Road to South Road. Willow Cottage (also shown in the inset) was demolished in 1970, and the site today has been absorbed into the Sturton Place complex.

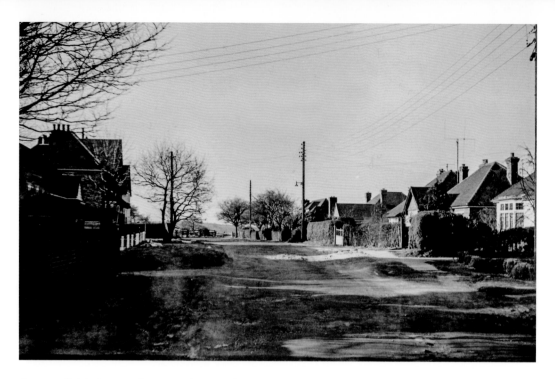

## Summerfields Avenue from London Road, 1965

An unsurfaced road, with fields and a view, Summerfields Avenue was a short cul-de-sac of houses and bungalows. Little changed until the late 1960s when Forest View and Woodpecker Drive were built. Facing Summerfields Avenue, set in the London Road verge, is a replica of an eighteenth-century milestone (see inset). It shows the distance to Bow Bells as 55 miles, and also depicts a buckle which was the badge of the prominent local landowning family, the Pelhams.

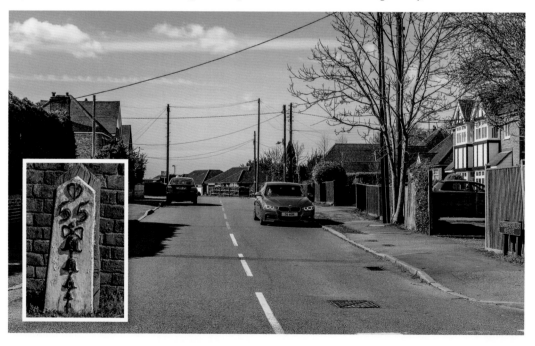

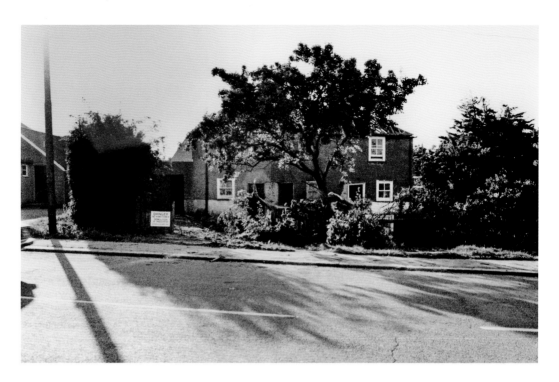

**Summerheath Road, America Cottages**

Little is known about the origins of these cottages, which stood next to Summerheath Hall, or why they were so named. Perhaps they were built for the Barracks on the south side of London Road on the Common from 1800 – the cottages were beside the old road which crossed the Common before the Enclosures. Eastwell Place originally crossed the railway at the America (or 'Merricky') steps, and the schoolchildren who used the path were known as 'from America'.

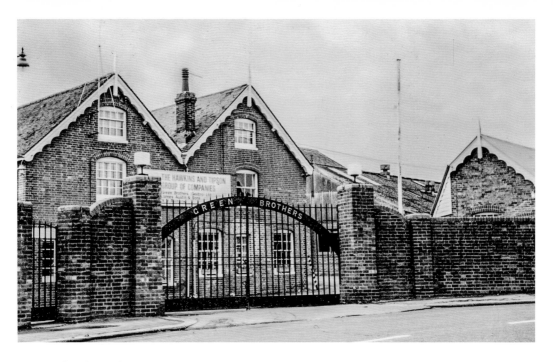

**Summerheath Road, Green Bros Entrance, 1983**

Green Bros, founded in 1830, produced rope, twine, sacking, trugs, matting, and furniture. During the First World War they made airship hangars and army tent pegs. During the Second World War they supplied coconut matting for tank river crossings and airstrips, and decoy aircraft for display on dummy airfields. They were one of the largest employers in the town and moved to the Marlow Ropes factory at Ropemaker Park. The Summerheath Road site was redeveloped as Beuzeville Avenue in the 1980s.

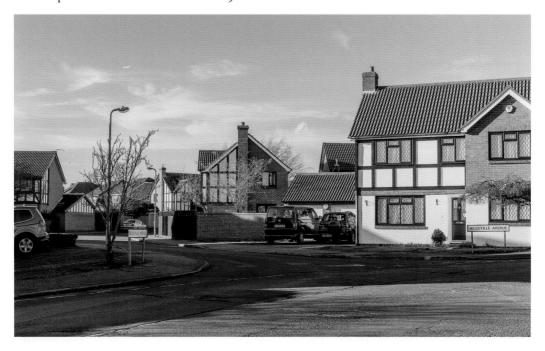

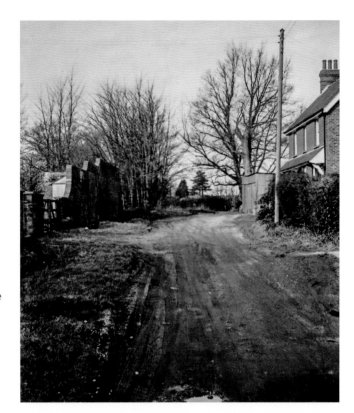

**Vicarage Lane, The Vicarage and Seaforth Farm, 1965**
In dry weather this was a pleasant, almost rural, walk, when Seaforth, on the right, was a working farm and Vicarage Field a grassy meadow. But the big change was about to begin when this photograph was taken in 1965, with the start of work on the Vicarage Field development. Today the vicarage wall remains, but the Seaforth frontage has been tidied up with the hedge replaced by a wall.

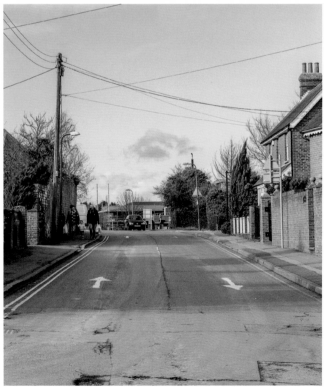

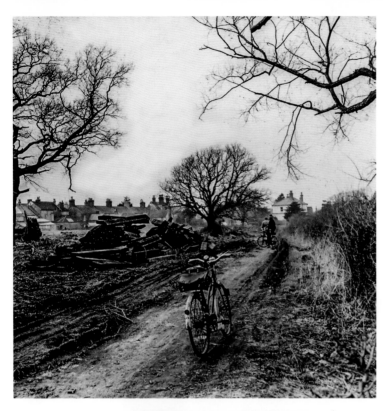

**Vicarage Lane towards St Wilfrid's, 1965**
Suitable for bicycles but not recommended for cars! Another view of Vicarage Lane in 1965, showing that the clearance of Vicarage Field is underway. Visible on the left are the backs of the High Street buildings. The white house at the end of the lane is St Wilfrid's.

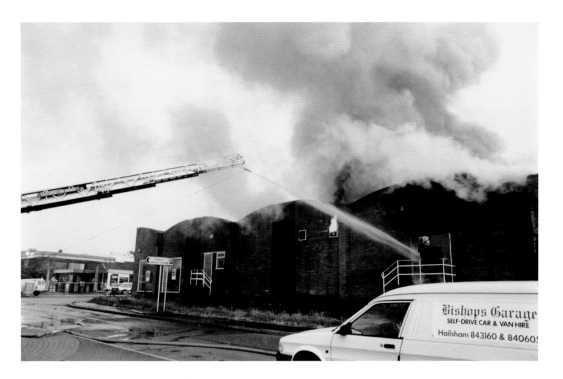

**Vicarage Lane, Gateway Fire, 1992**

One of the memorable things about the fire was the tantalising smell of cooking as the contents of the Gateway store burned furiously on the evening of the 25 June. Fortunately there were no casualties, and the severe damage to the building provided an opportunity for redeveloping the site, including the demolition of Bishops Garage (left background) to form a larger car park and superstore. The plaque in the paving on the left covers a 'time capsule' buried in 1990.

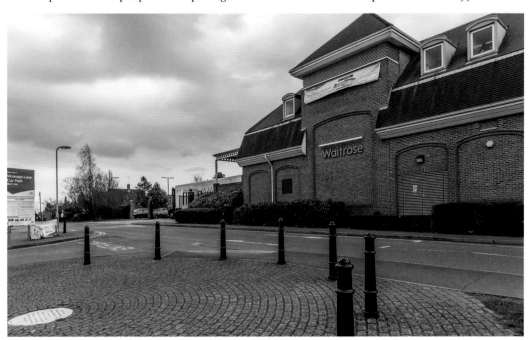

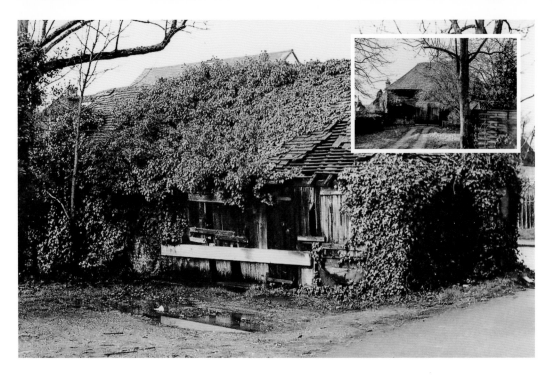

### Vicarage Road, Town House Barns, 1992

These barns, originally a granary and animal sheds, formed part of the old Town Farm on land owned by the Duke of Devonshire, which was sold by auction in 1924. The barn was used for various purposes, including a cycle repair workshop in the seventies but it was in poor condition and one part was left to collapse. Permission was given in 1986 to convert the granary to a dwelling, but houses were built on the site in the 1990s.

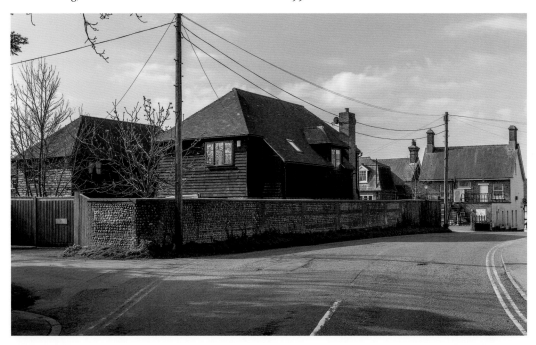

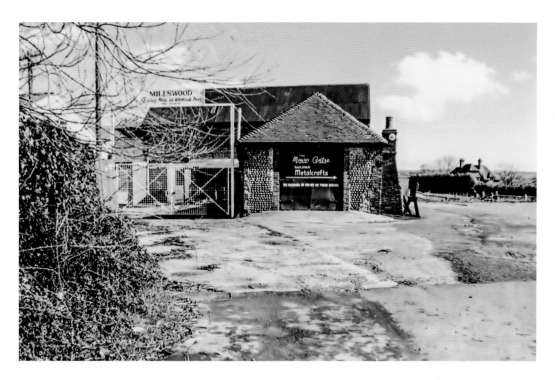

**Vicarage Road, Chapel Barns, April 1987**

The original flint barn, thought to have been used as a chapel, now the Mower Centre, is all that survives of the extensive buildings that once housed the abattoir just behind the market in the town. This was also once part of Town Farm and there were extensive views across the marsh to Herstmonceux and beyond from the car park, until housing surrounded the site when Greenacres Drive was built in the 1990s.

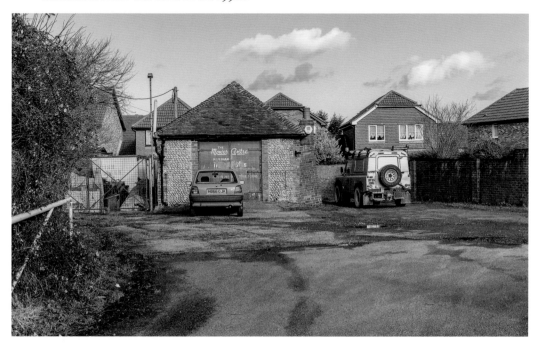

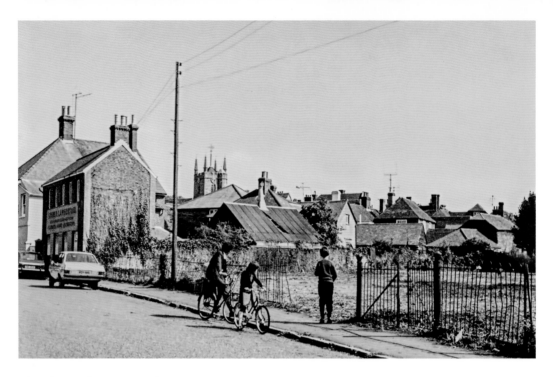

**Victoria Road, August 1978**

This land was at one time allotments, but by 1978 was derelict and was to be made into a car park. We have an interesting view of the rear of the George Street buildings, including the tin hut with stovepipe, in the centre of the picture. This had been Miss Emily Bray's ladies' school, which she ran from around 1880 to 1930. It was soon to be demolished, along with Fairlight House, and replaced by the much larger Wentworth House.

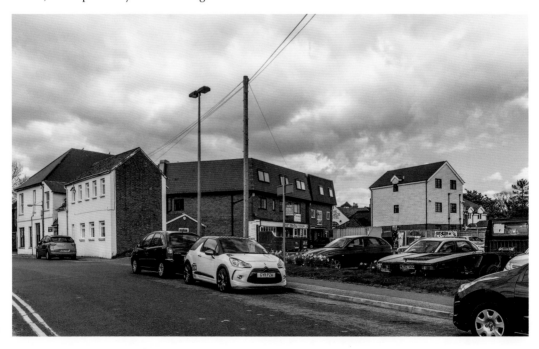

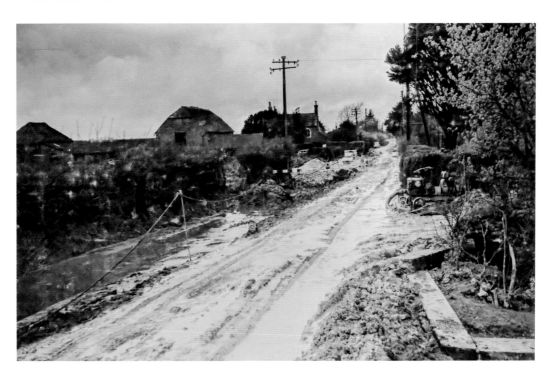

### Western Road, Diplocks Farm, 1966

If you lived in Western Road, you would have had to wear wellingtons and drive a 4x4! The road had a number of houses and was probably nearly a mile long, but it was not made up until the housing developments of Sussex Avenue and The Diplocks were started in the late sixties. Cars often got stuck in the mud and some were quite badly damaged in the deep potholes, something quite difficult to believe looking at the present-day view.

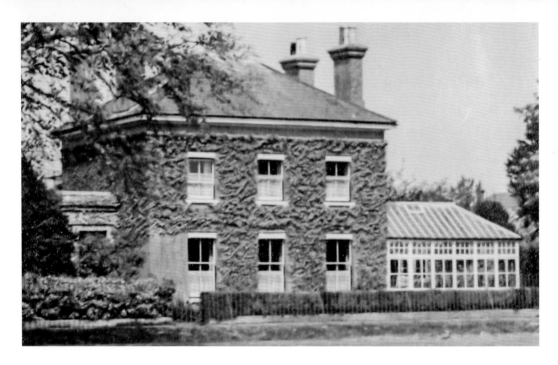

**Western Road, Downs View, 1930s**

A pleasant creeper-clad villa, facing southwest, with a view of the distant Downs. Adjoining it was Hailsham Lawn Tennis Club and when Downs View was demolished in the 1960s the whole area was redeveloped as Downsview Way and Tennis Close. The library was opened on 6 September 1971, replacing the previous public library in the Memorial Institute. In front of the library is the Community Rose Garden, opened 2 June 2012 to commemorate the Diamond Jubilee of Queen Elizabeth II.

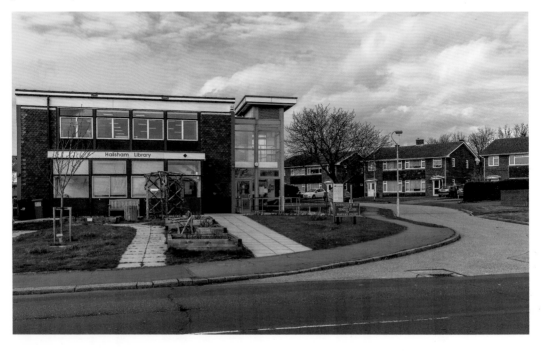